MW00364088

MIAMI BEACH DECO

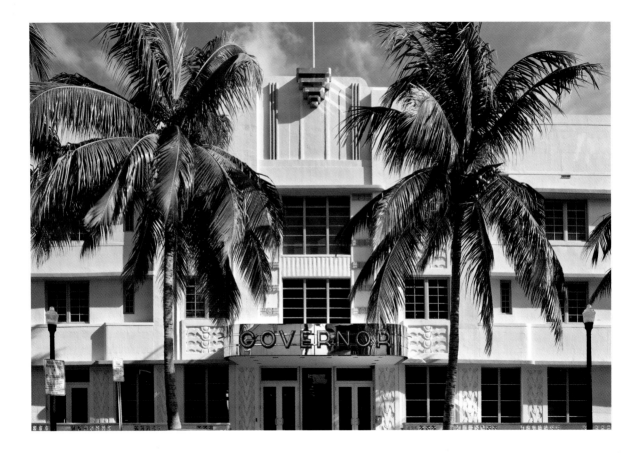

MIAMI BEACH DECO

STEVEN BROOKE

Foreword by Beth Dunlop

UNIVERSE

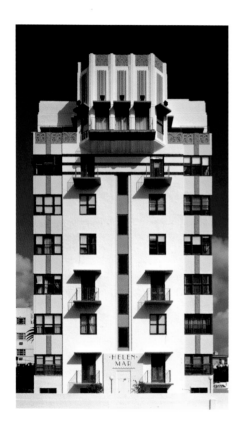

First published in the United States of America in 2011
By UNIVERSE PUBLISHING
A Division of Rizzoli International Publications, Inc.
300 Park Avenue South, New York, NY 10010
www.rizzoliusa.com

© 2011 Rizzoli International Publications, Inc.
Text and photography © Steven Brooke
Designed by Steven Brooke Studios/www.stevenbrooke.com

All rights reserved. No part of this publication
may be reproduced, stored in a retrieval system,
or transmitted in any form or by any means, electronic,
mechanical, photocopying, recording, or otherwise,
without prior concent of the publisher.

Distributed to the U. S. Trade by Random House, New York

Front cover: Collins Park Hotel, detail
Back cover: Detail of Carlyle Hotel, Ocean Drive
Endpapers: Frieze, 1000 Lincoln Road
Page 1: Ceiling detail of Sterling Building, Lincoln Road
Page 2: Detail of Governor Hotel
Page 4: The Helen Mar

ISBN 978-0-7893-2241-8
Library of Congress Control Number: 2010931542
Printed and bound in China
2011 2012 2013 2014 2015 2016/ 10 9 8 7 6 5 4 3 2 1

For Mollie and Nat

ACKNOWLEDGMENTS

I wish to extend my gratitude to all the heroic pioneers
of the movement to save the Art Deco District.
In particular, I honor the memories of
Barbara Baer Capitman and Leonard Horowitz.

I extend my deepest gratitude to my colleagues
at Rizzoli: David Morton, Douglas Curran, and Charles Miers,
for their continued encouragement and support of my work.
My thanks to James Wasserman of Studio 31,
Lewis Feldman of Fine Arts Photographers,
and Dennis Wilhelm for their assistance;
and to Donna Fields of Brockway Fields
Communications for her reviews and suggestions.
S. B.

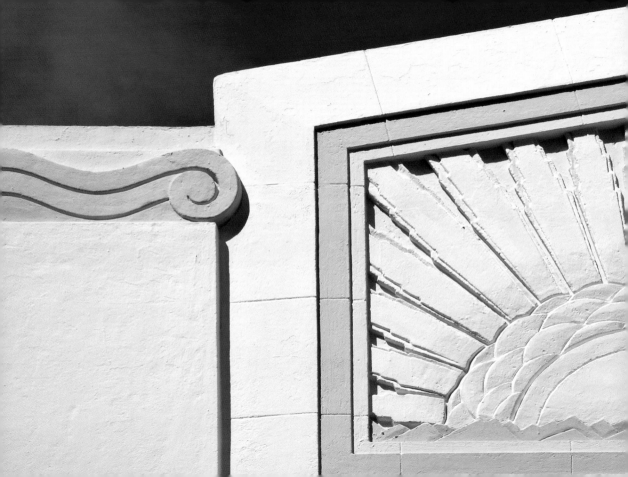

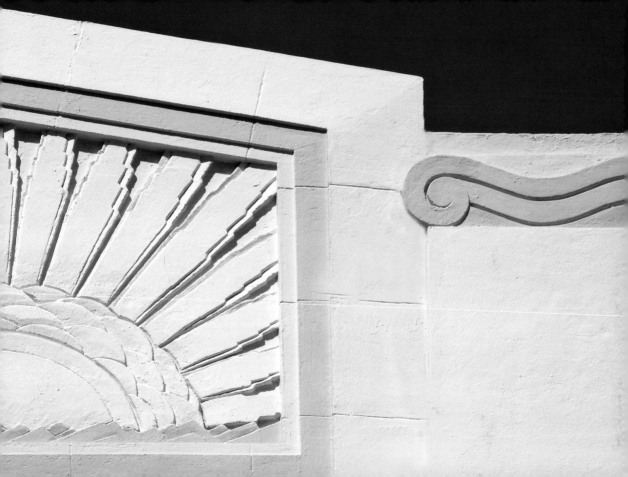

FOREWORD
Beth Dunlop

MIAMI BEACH'S ART DECO architecture offers a testament to the power of architecture to uplift and restore the human spirit, an ode to the way we ultimately can triumph over adversity. The buildings within the mile-square precinct officially known as the Miami Beach Architectural Historic District (or so it is listed on the National Register) were almost all constructed during the darkest period of modern history, the years that encompass both the Great Depression and the onset of World War II. It was left to the arts—to jazz music, to films and Broadway musicals, especially, and to architecture—to express not just hope, but joy and optimism, in a time when those were fleeting commodities.

The buildings are little jewels, low-slung with geometric banding and finials and spires that thrust skyward in homage to the skyscrapers other cities were erecting in the Deco style; in these stucco beauties, however, the horizontal and vertical create a kind of compression that gives them a taut, energetic presence—as if they were chorines poised to break into a tap dance. There's a rhythm to it all, punctuated by flat concrete eyebrows over windows, etched glass, porthole windows, and decorative stucco. Only a handful of architects worked on the buildings shown here (primarily Henry Hohauser, L. Murray Dixon, Anton Skislewicz, and Albert Anis, among them), and the miracle is—at least filtered through the ethos of our era—that they worked so beautifully together, to create a district so seamless.

Walk the streets of Miami Beach's Art Deco District today, and it is certain that this square mile of architecture will seduce you.

But it was not always this way. The first time I saw the Deco district was well before it was known as such. I recall driving slowly through Miami Beach, a newcomer gazing out at the low-slung stucco buildings. They were decrepit, having been left to languish over the decades, building details obscured by layers of drab peeling brown and beige paint. There was little to redeem the place—unless you looked carefully. There, buried under the decades of dirt and disrepair, were the details: elegant bas-relief friezes, delicate tinted inlays of carved native rock, and, in metal or concrete or stone, exuberant "frozen fountains"—that spray of geometry that was the emblem of the 1925 Exposition Internationale des Arts Décoratifs et Industriels in Paris, the fair that brought us the style that years later became Art Deco.

The buildings on these pages, photographed with both artistry and passion by Steven Brooke, are those same buildings transformed—the product of a slow miracle that has taken three decades and which has reinvigorated the mile-square neighborhood, turning it into an internationally renowned historic district: evidence of the power of architecture to prevail against troubled times. We owe it to Barbara Capitman, who first saw here a treasure-trove of neglected Art Deco, and who in 1979, envisioning what it could be, fought to make the neighborhood a National Historic District—and to the others who stood with her in the face of ridicule and wrecking balls to preserve it then. I have been fortunate enough to chronicle the story of regeneration and hope over the past several decades, and the effort never ends. But in these photographs one can capture the prime moment—the beauty and poetry, the joy and whimsy, even the irony and poignancy of the architecture—and know why it is all so worthwhile.

.

MIAMI BEACH DECO
Steven Brooke

MY FASCINATION WITH DECO, Streamline, and Modernist design began in my childhood in Detroit, a city graced by some of the world's finest Art Deco architecture such as the Penobscot Building and the Fisher Building. These buildings embraced technology, symbolized limitless progress, conveyed indomitable optimism, and promised a sleek and smart future.

I took my first trip to Miami Beach before the onset of the Art Deco District restoration movement. On that late summer afternoon over forty years ago, I crossed the bridge over Biscayne Bay, and drove east on 5th Street. As I turned north on Collins Avenue I discovered a parade of fantastic buildings lit by a deep vermillion afterglow and imbued with the same spirit of the future that had fascinated and inspired me as a child.

I headed to the Beach the next morning, camera in hand. At each turn I was dazzled by futuristic spires, jazz-age ornamentation, rakish window treatments, gleaming aluminum railings, colorful terrazzo floors, and sparkling Vitrolite glass. I hardly noticed the peeling paint, cracked plaster, and broken Park Avenue-style letters that characterized the district at the time. I wondered why these extraordinary buildings were in such dilapidated states. I learned that many locals considered them ugly, and hardly worth saving. Home to an aging clientele, the district was often denigrated as "God's Little Waiting Room."

Years later, when the movement to save the district began, I was eagerly on board. I photographed the first restored buildings whose sophisticated 1930s World's Fair color schemes

were created by Leonard Horowitz, a designer and colorist of imagination and passion.

My photograph of "Friedman's Bakery" on the corner of Washington and 6th Street appeared on the cover of the November 1982, issue of *Progressive Architecture*. Such national recognition by a respected architecture journal signaled to the architecture community, which long dismissed deco architecture as overwrought kitsch, that the Art Deco District was a valuable repository of architecturally significant structures well worth preserving. The article lauded the exceptional talents of architects such as Henry Hohauser, L. Murray Dixon, and Anton Skislewicz, all of whom masterfully blended dynamic decorative treatments with a refined sense of scale.

Spearheading the preservation movement was the legendary doyenne Barbara Baer Capitman. Her disheveled appearance, seemingly scattered (it wasn't!) focus, and oddly crackling voice spawned ruthless caricature. Dogged and persuasive in the political trenches, Barbara and others such as Dennis Wilhelm, Michael Kinerk, Laura Cerwinkse, and R. Thorn Grafton fought to have the district designated an official National Historic District. Without the protection afforded by such designation, the first given to a post-1900 neighborhood, the Art Deco District as we know it would certainly not exist.

Barbara and I collaborated on *Deco Delights* (E. P. Dutton, 1988), the landmark book chronicling the history of the district and the struggle to save it. *Deco Delights* brought much-needed attention to the district. However, the single event that carried South Beach to national and international prominence was the production of Michael Mann's flashy television series, *Miami Vice*. The high-styled crime drama was set against the backdrop of the pastel-colored Art Deco architecture. South Beach was the real star of the program. Sparked by the district's weekly exposure, the demand from magazine and book editors for photographs of the district increased, tourism surged, restoration efforts accelerated,

and local interest was finally kindled. Ironically, it took recognition from the outside world to awaken Miamians to the importance of their neglected architectural heritage.

Today, South Beach is a nexus for film makers, advertising agencies, and fashion designers eager to use the quintessentially stylish district as a background for their creations. Where once there were only one or two outdoor restaurants, today almost every Ocean Drive hotel features sidewalk dining. Proponents of modernist design, often chastised by traditional urban planners as incapable of creating humanely scaled environments, point to the district as an example of appropriately scaled modernist buildings creating genuinely accessible urbanism.

In the mid-1990s the district underwent regrettable stylistic incarnations largely due to the ease with which the buildings could be painted. Designers and owners with more budget than taste colored every facet and protrusion, ignoring the high mark set by Leonard Horowitz's sophisticated design schemes. Thankfully, we have entered a more refined era. Many buildings such as the Delano and Tides are painted white with only a few color details.

Success should carry its own built-in protection. Yet, despite the district's popularity and fame, vigilance is still required to keep developers from destroying the very reason for the district's success. Buildings tragically lost include the New Yorker Hotel, a mid-rise gem on Collins Avenue, and the Senator Hotel, demolished to make way for a parking lot.

Miami has suffered from decades of less than memorable architecture designed by celebrated architects. Few, if any, of these structures are likely to be held in high esteem in years to come. The finest of Miami's architecture continues to be its pre-1950s Coral Gables Mediterranean Revival buildings, the tropical modernist residences of architects such as George Reed and Rufus Nims, several adventurous mid-70s modernist high-rises, and Villa Vizcaya. However, the

unique and defining treasure of Miami will always be its Art Deco District.

It is our civic duty to preserve the Miami Beach Art Deco District so that its remarkable exuberance and irrepressible style will continue to delight generations to come. Anyone may help the preservation efforts by supporting organizations such as the Miami Design Preservation League, the oldest Art Deco Society in the world. Founded by Barbara Capitman in 1976, the MDPL sponsors lectures, conducts tours, and encourages active community involvement on the local and national levels to protect our irreplaceable architectural and cultural heritage.

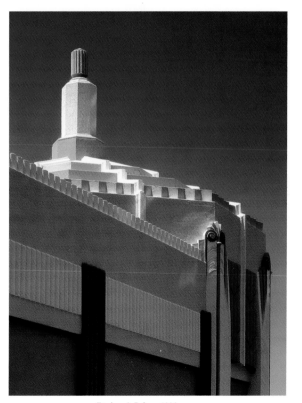

Friedman's Bakery, 1980

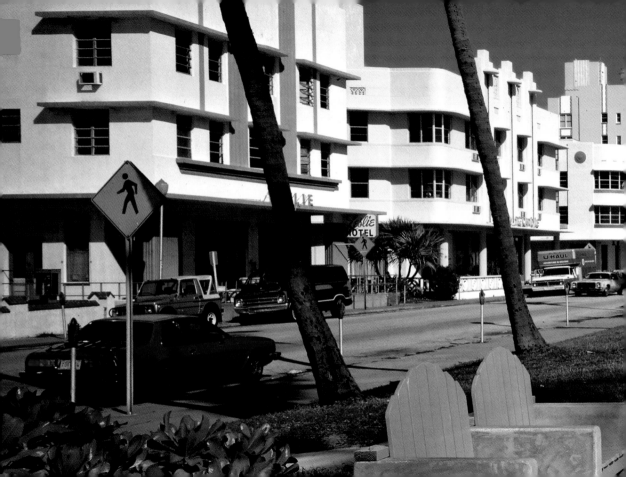

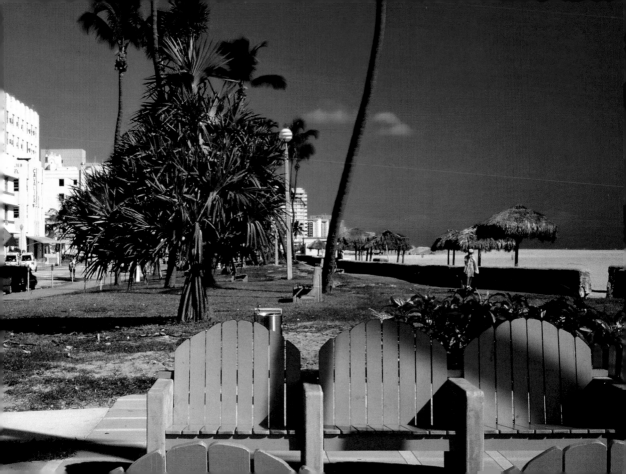

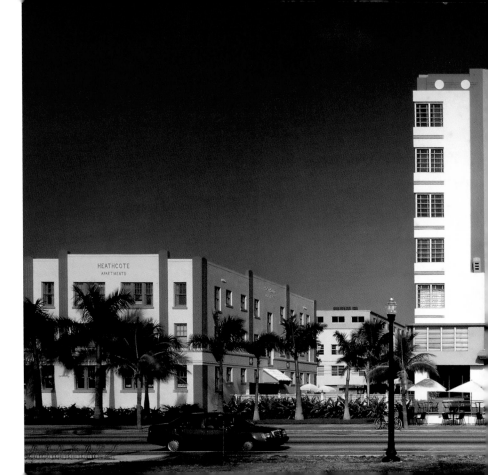

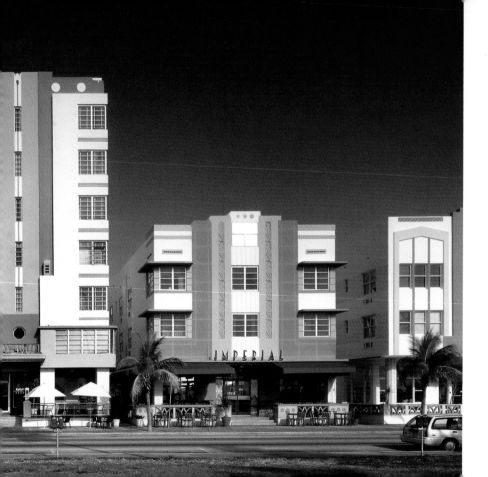

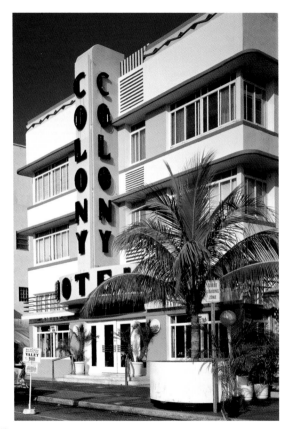

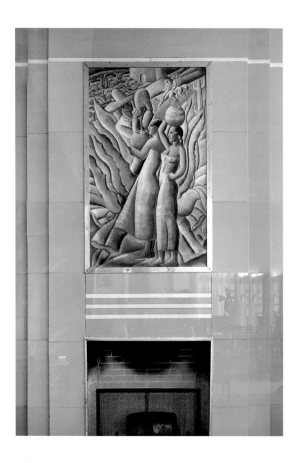

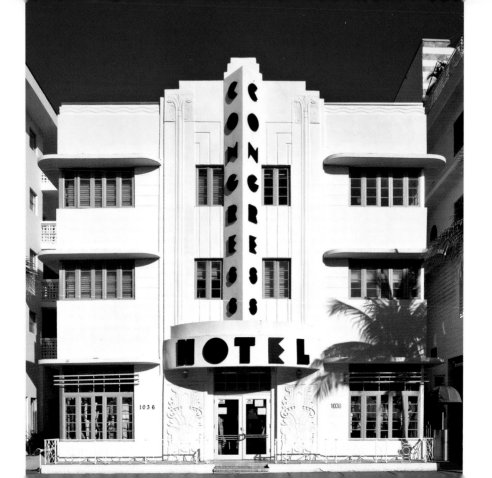

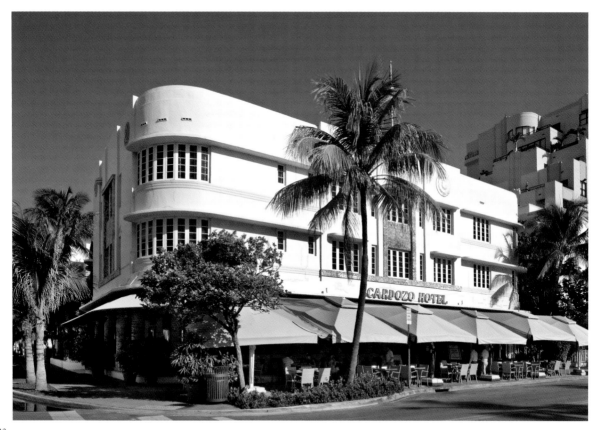

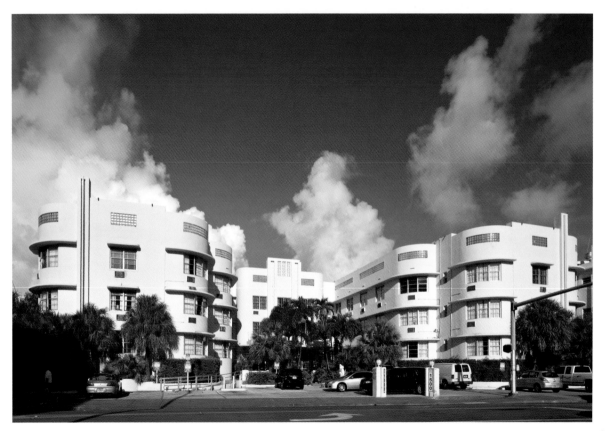

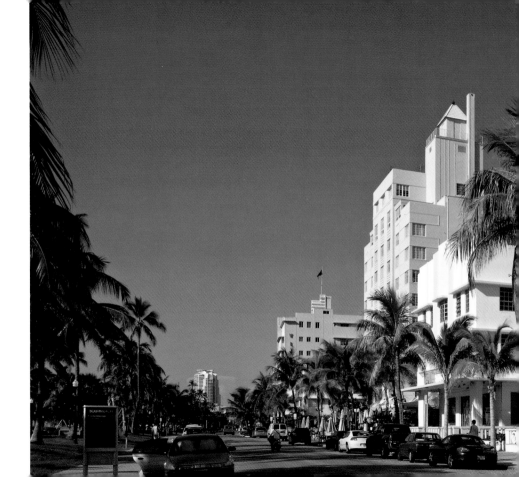

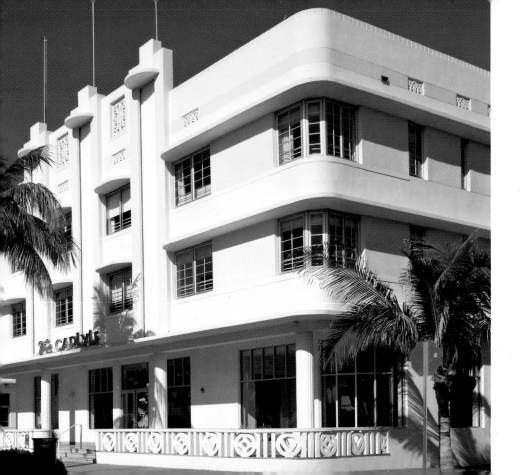

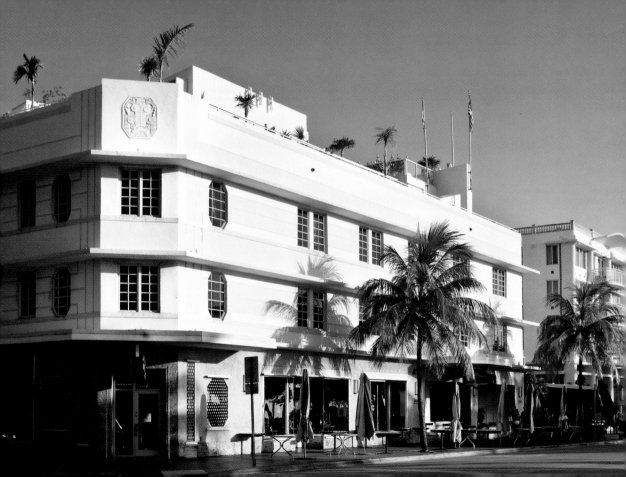

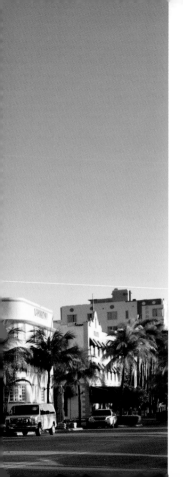
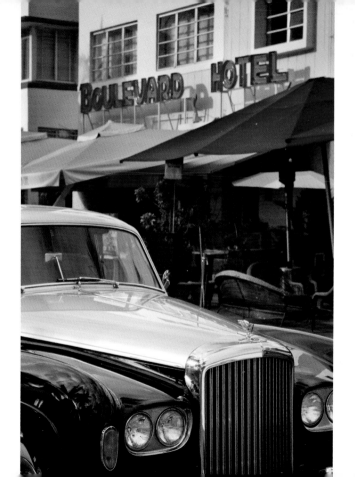

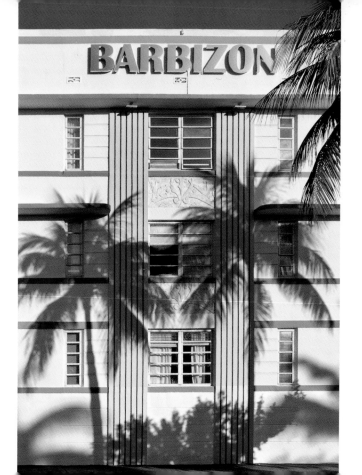

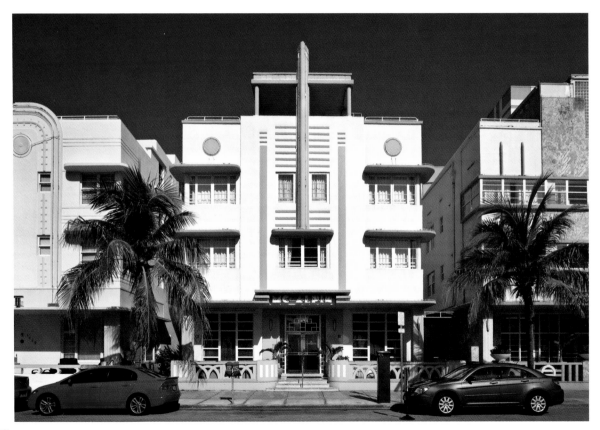

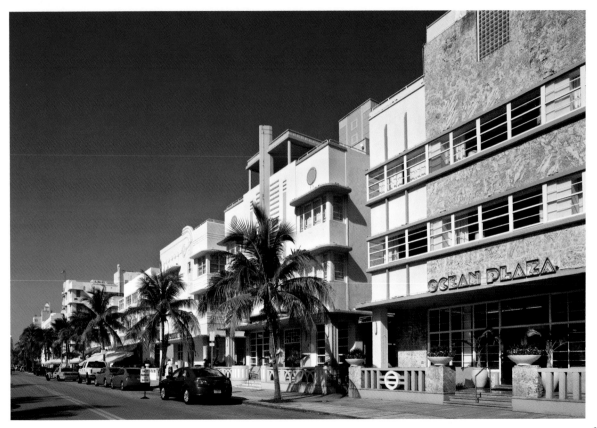

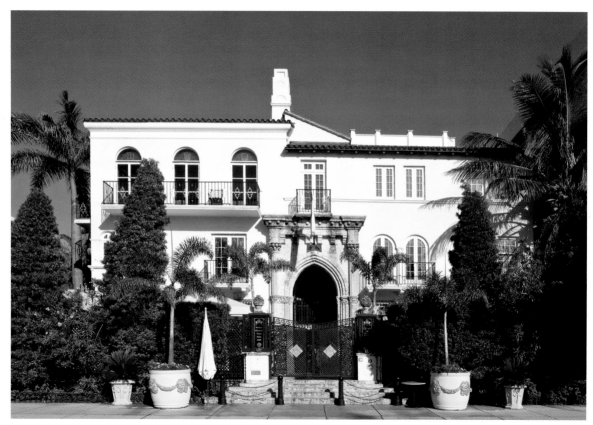

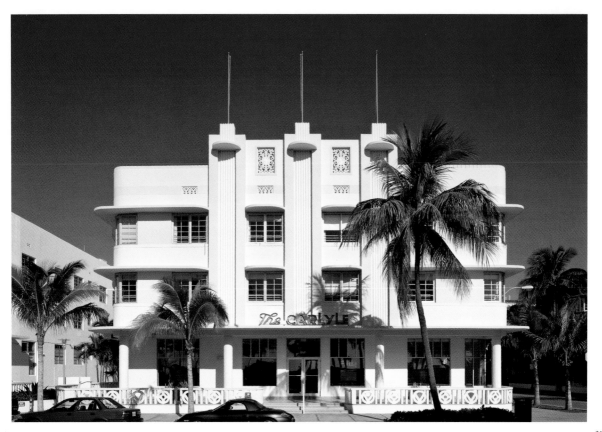

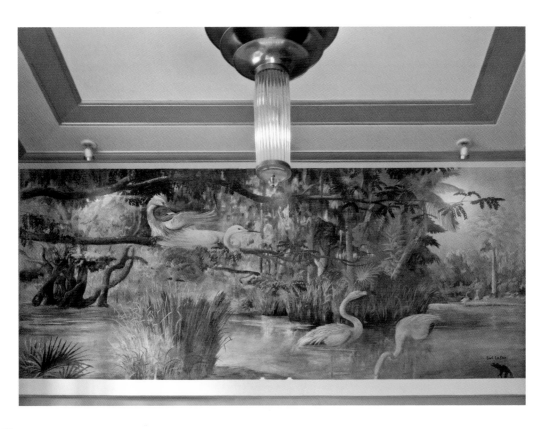

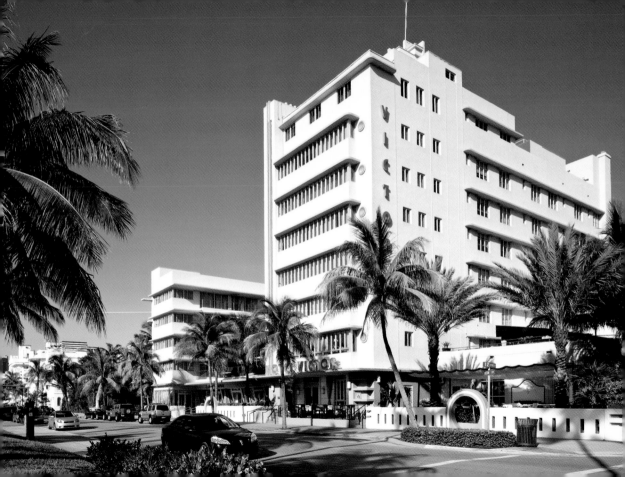

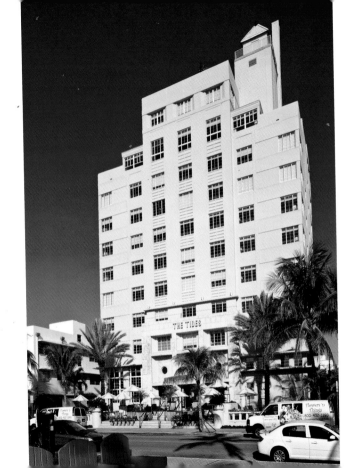

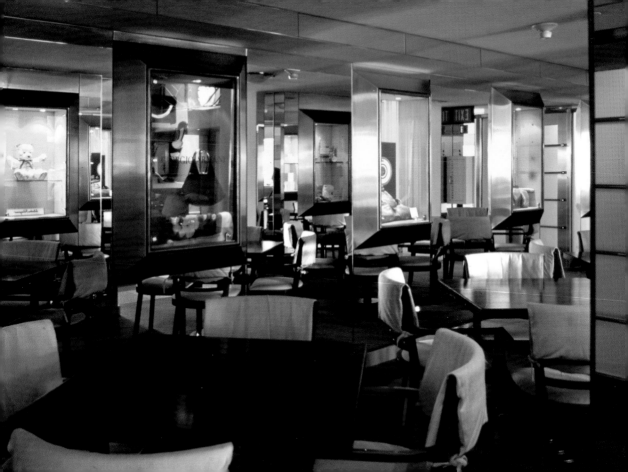

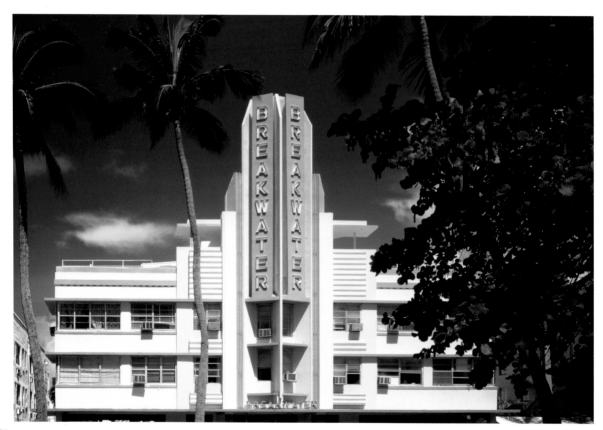

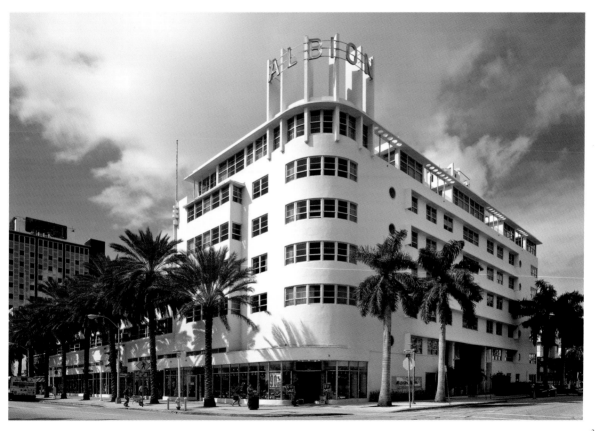

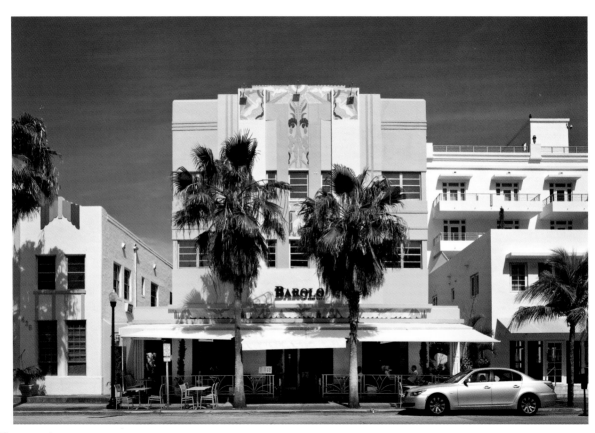

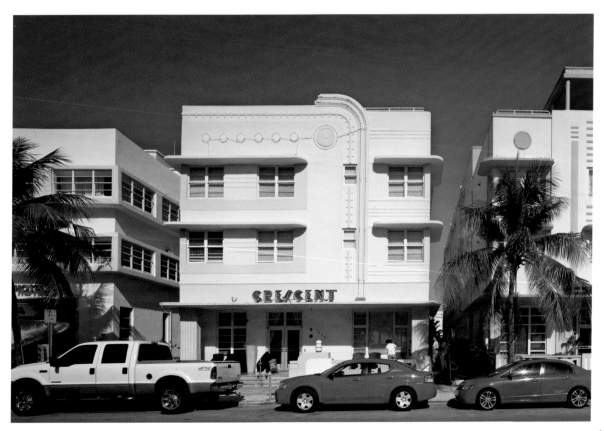

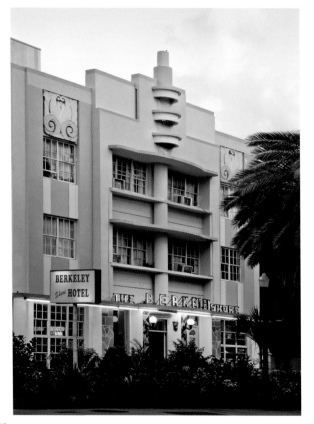

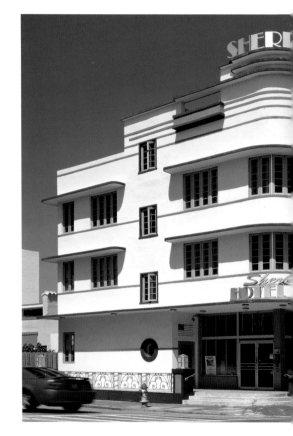

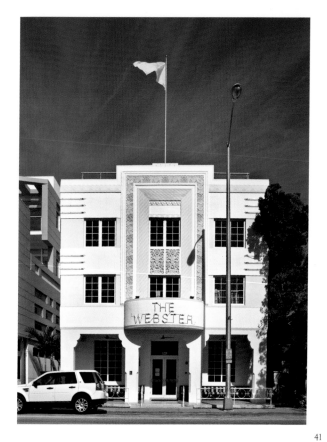

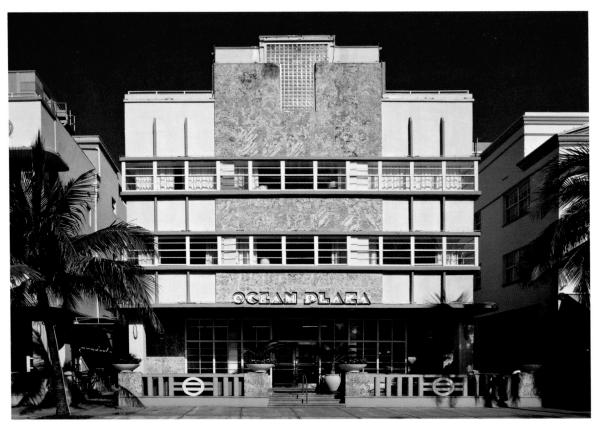

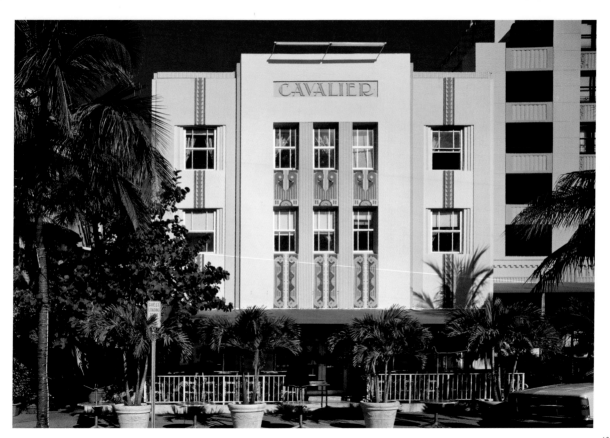

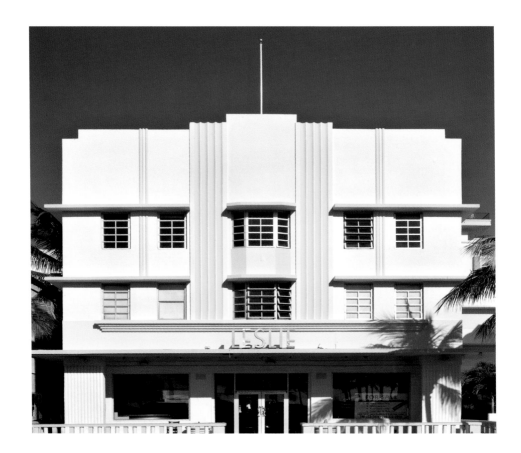

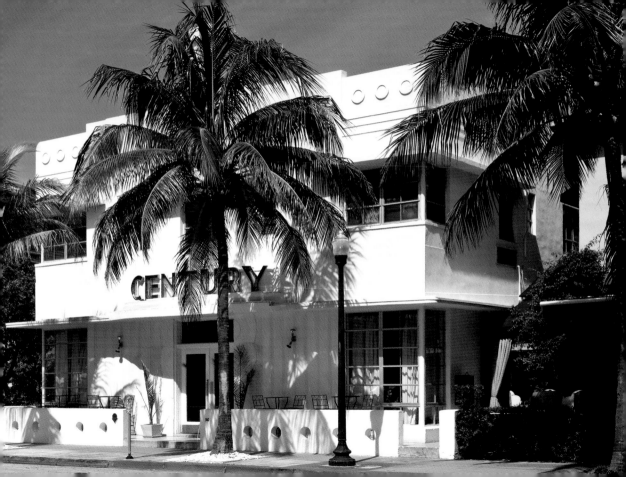

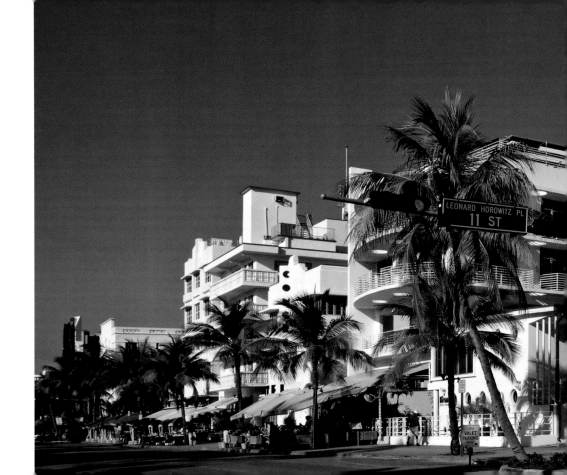

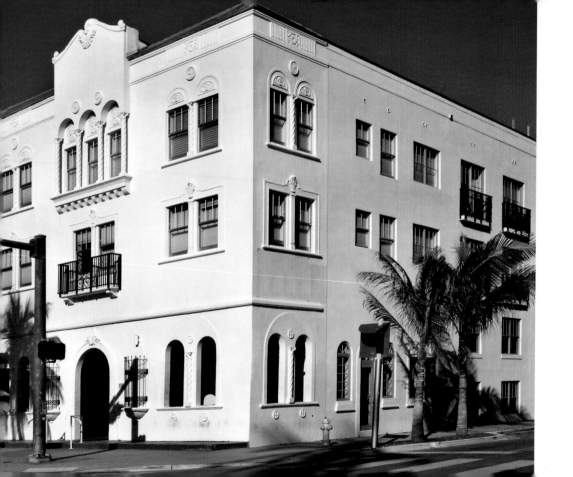

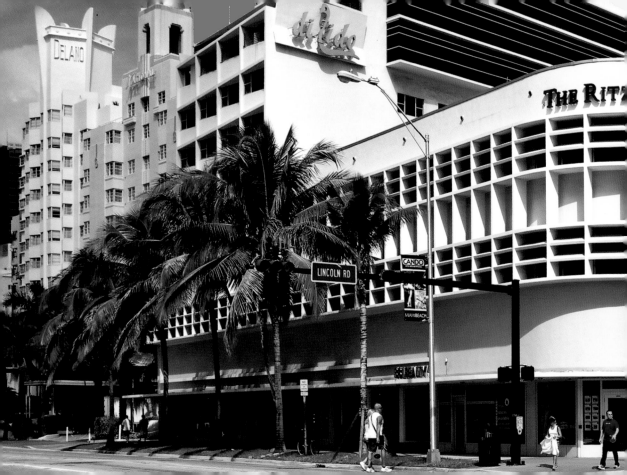

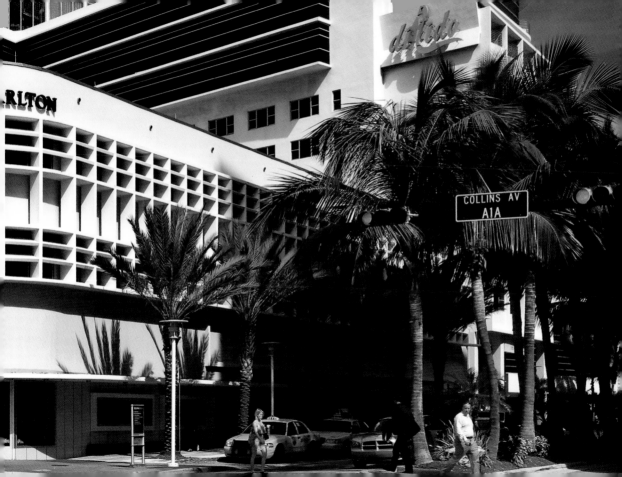

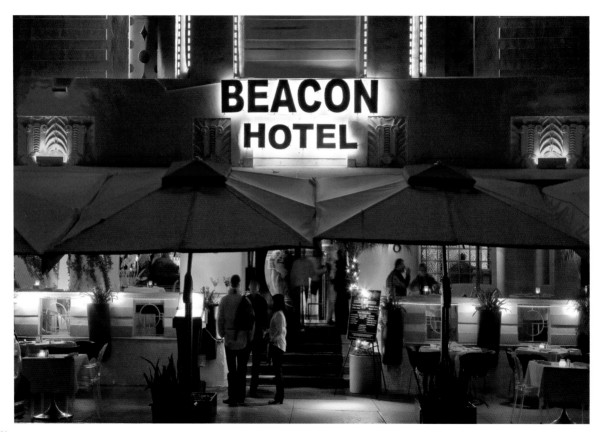

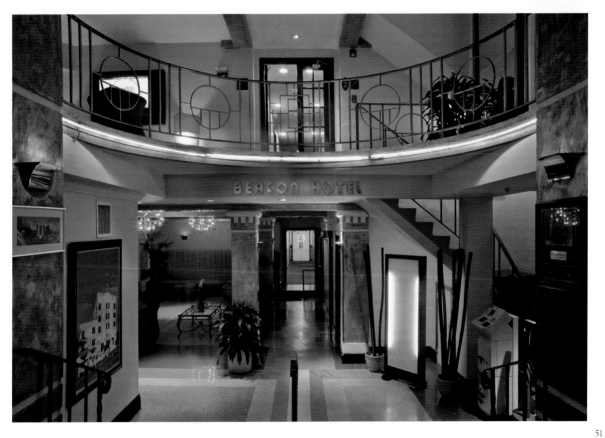

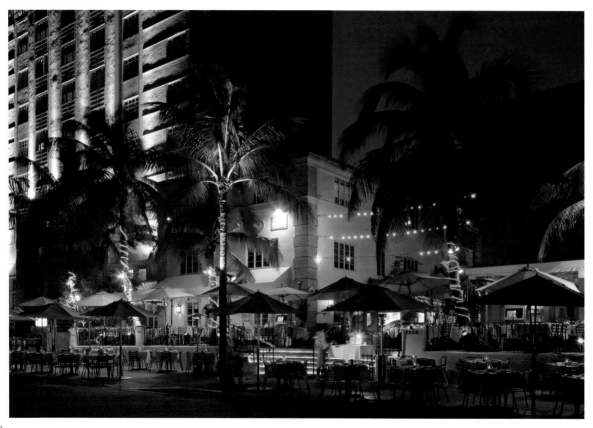

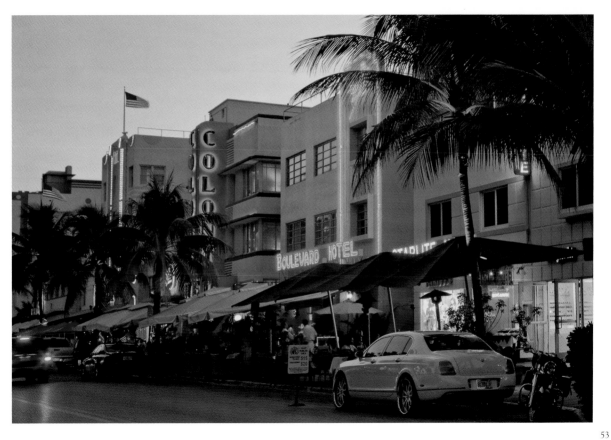

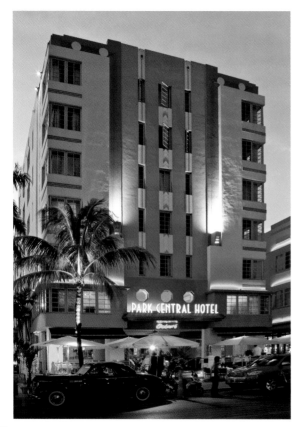

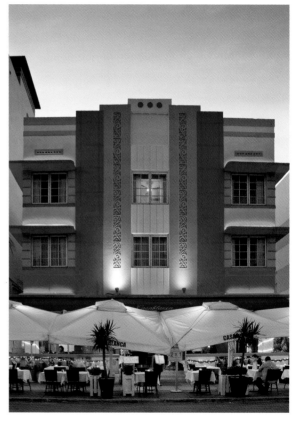

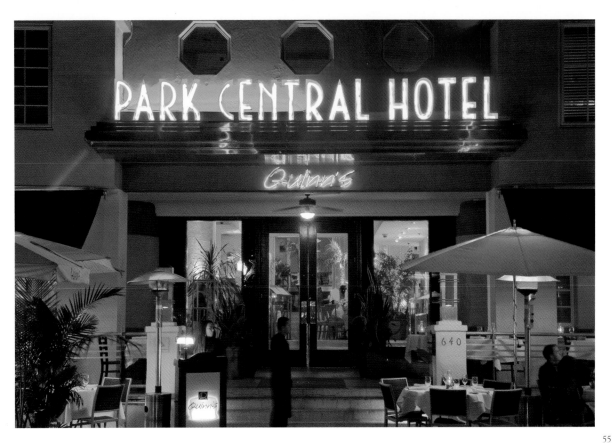

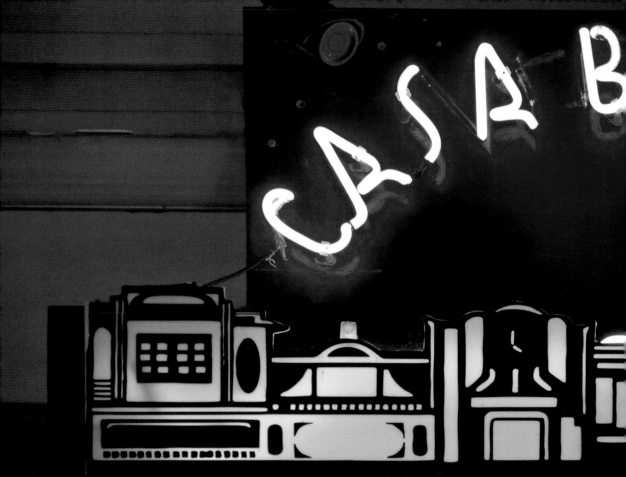

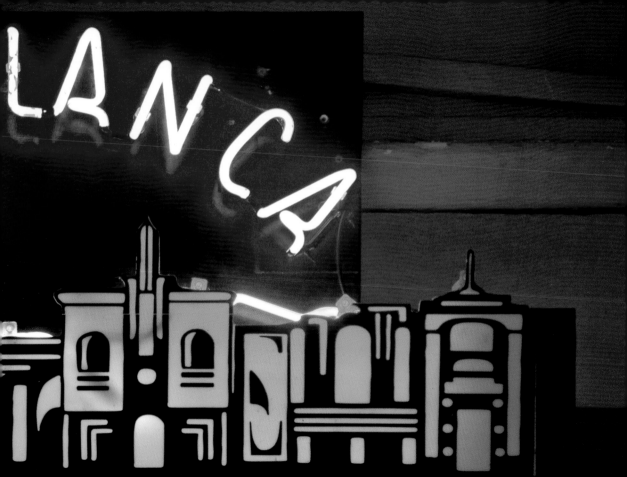

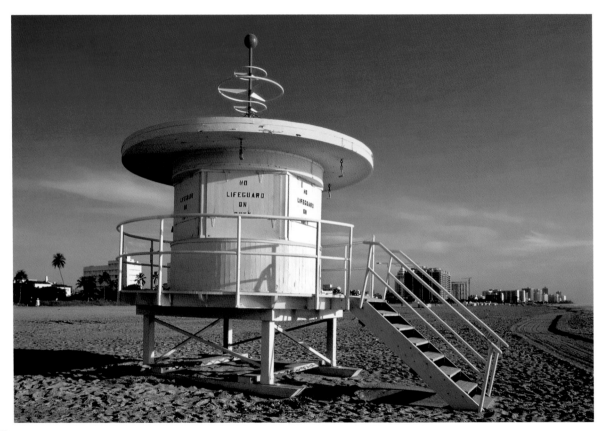

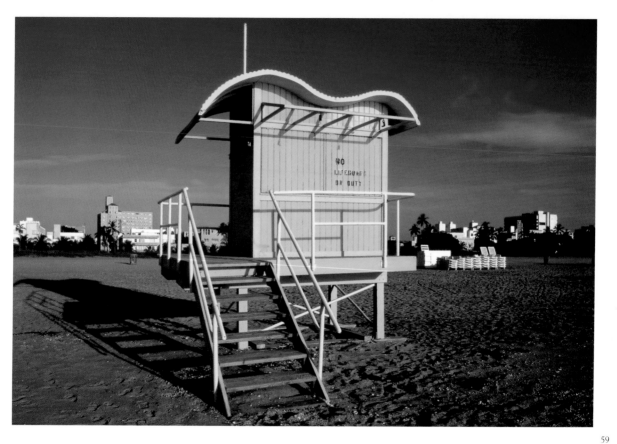

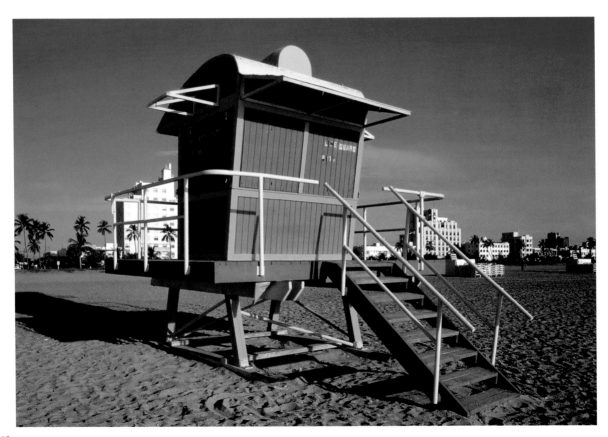

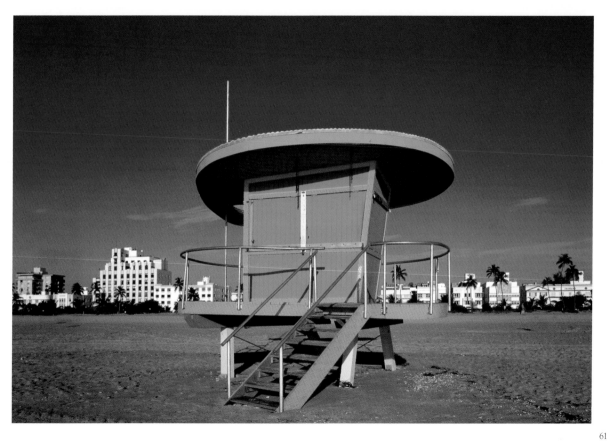

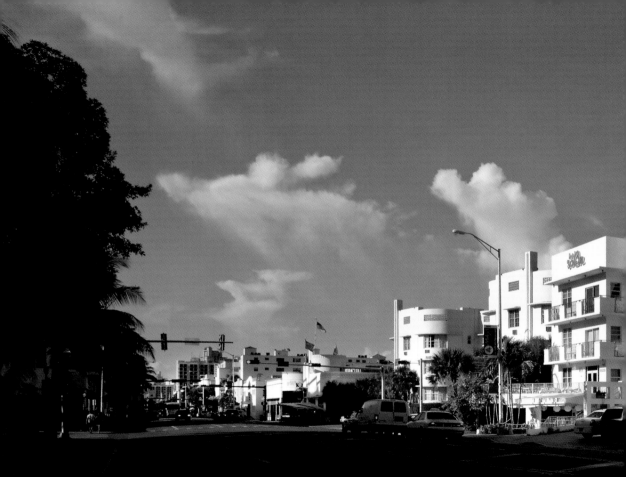

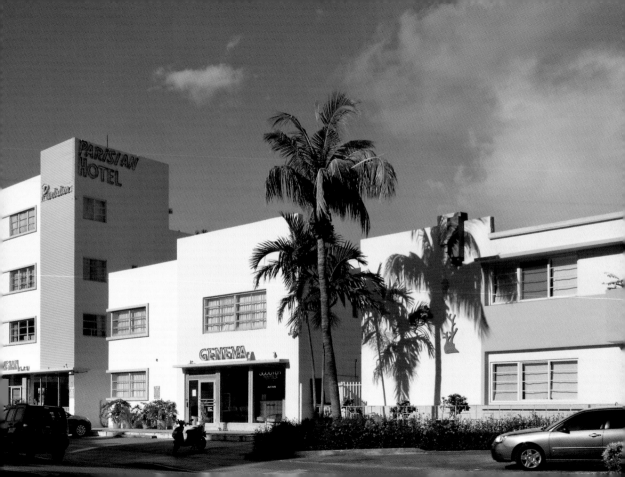

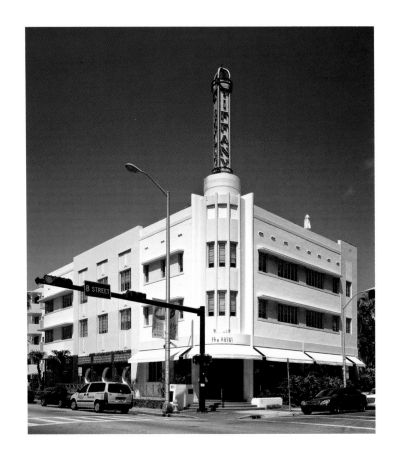

64

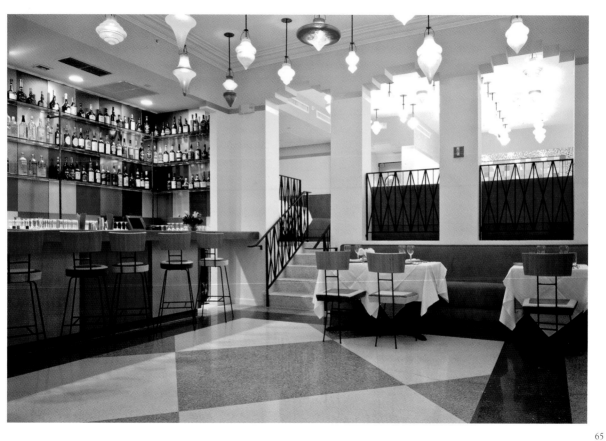

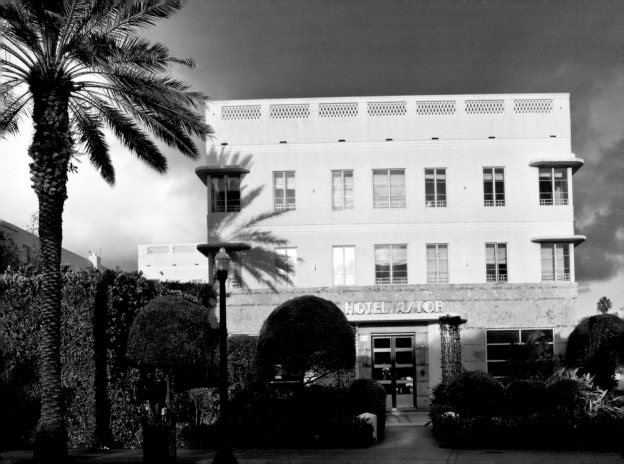

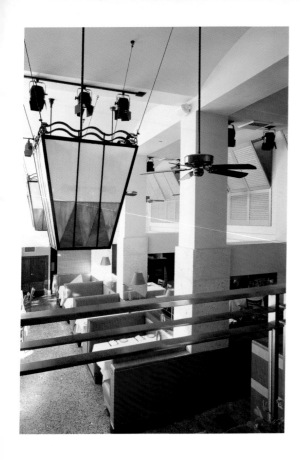

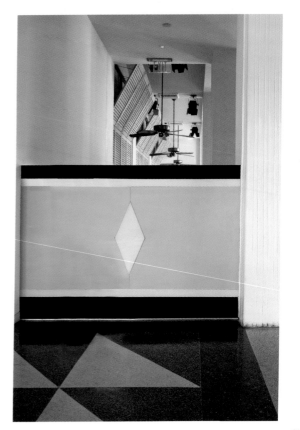

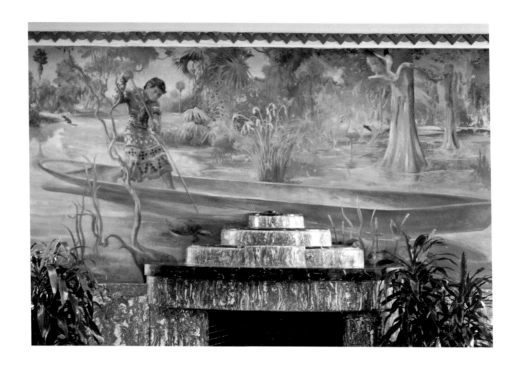

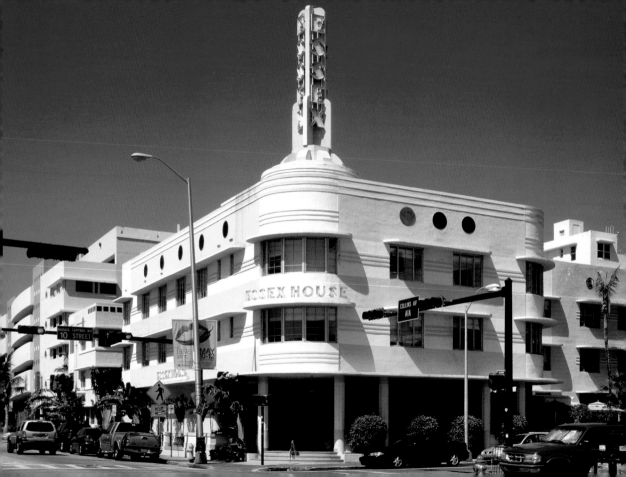

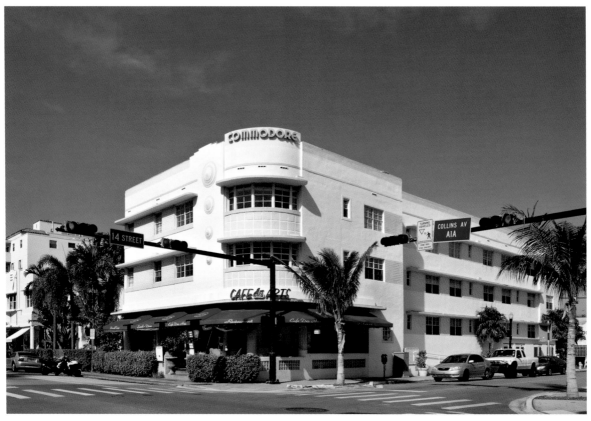

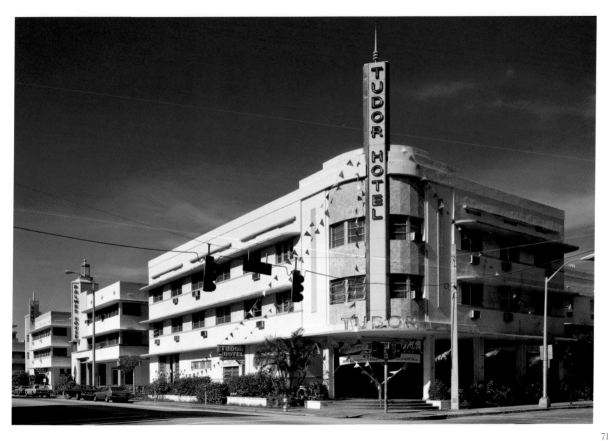

71

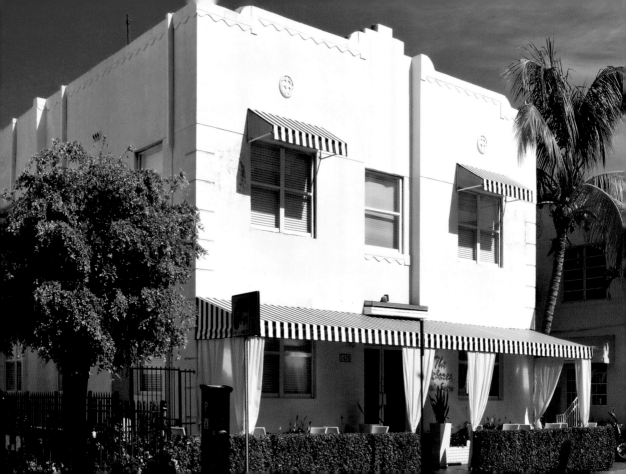

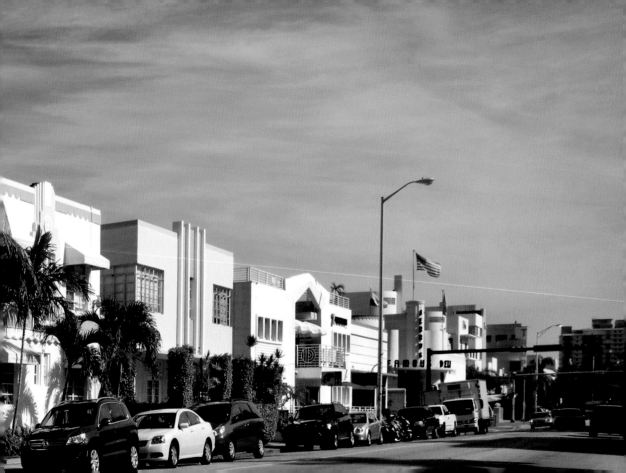

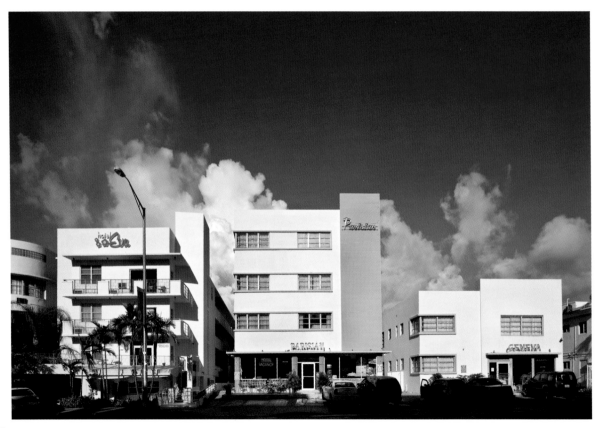

74

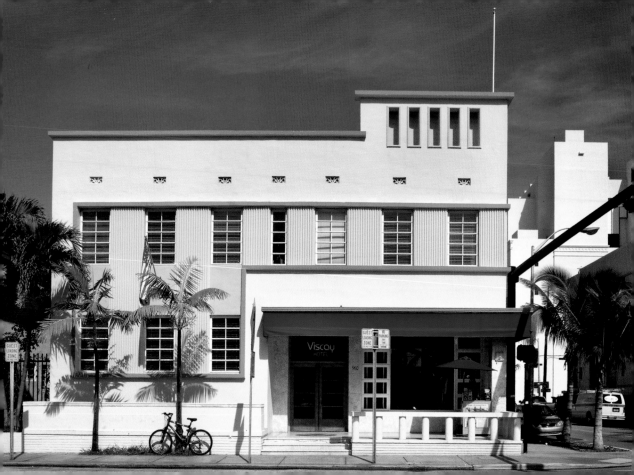

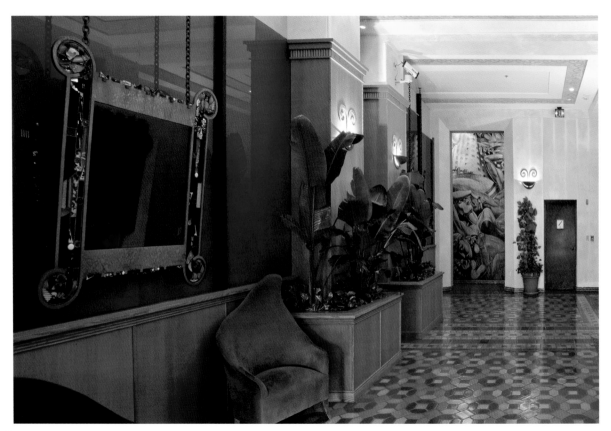

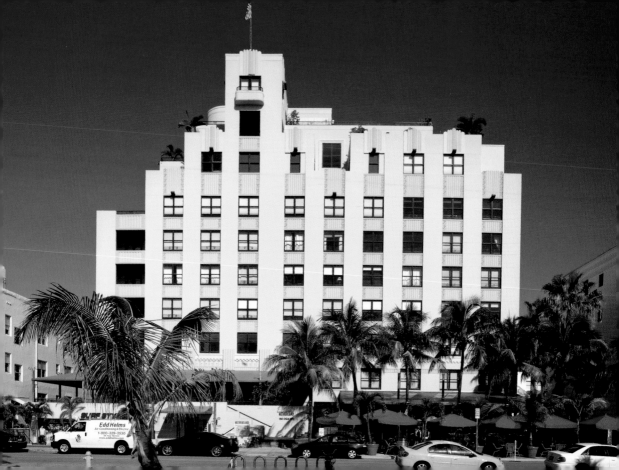

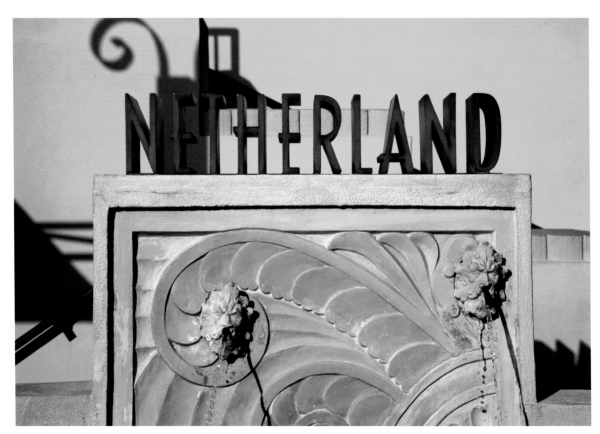

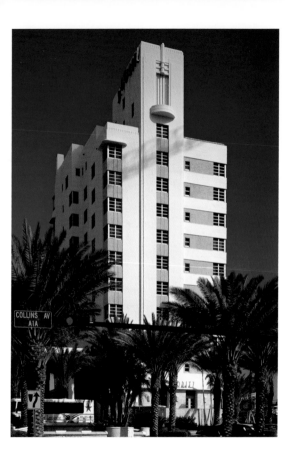

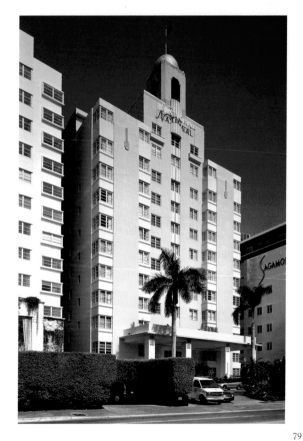

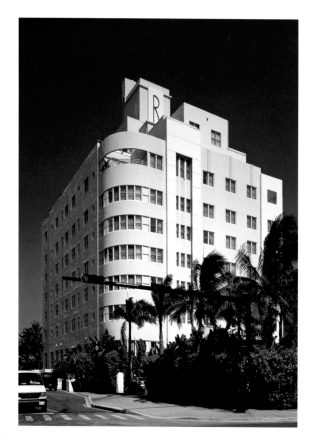

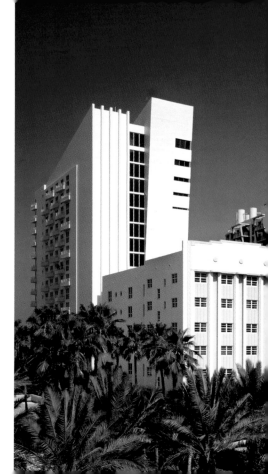

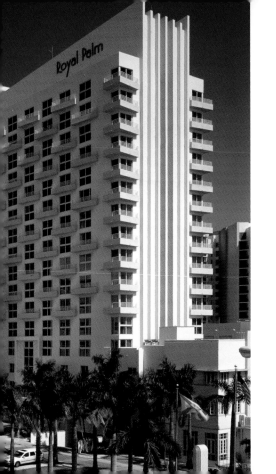

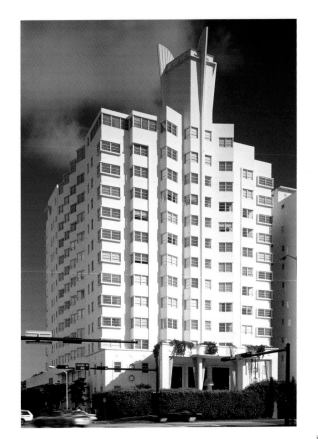

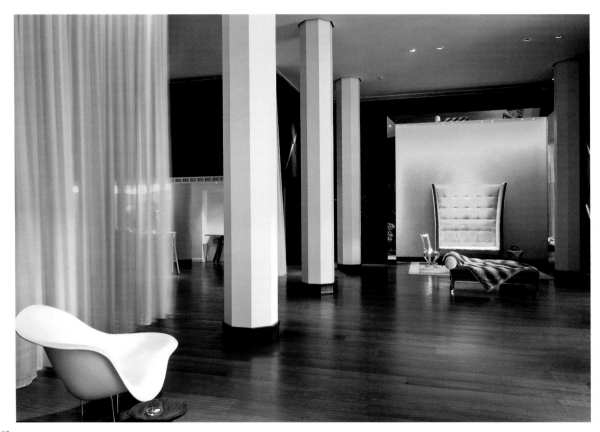

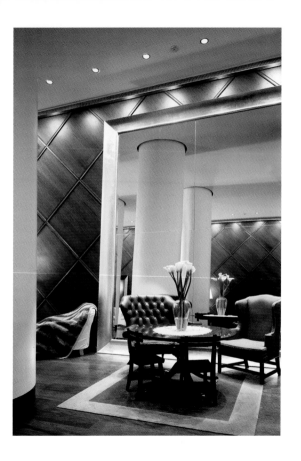
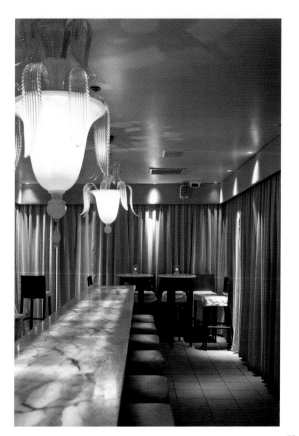

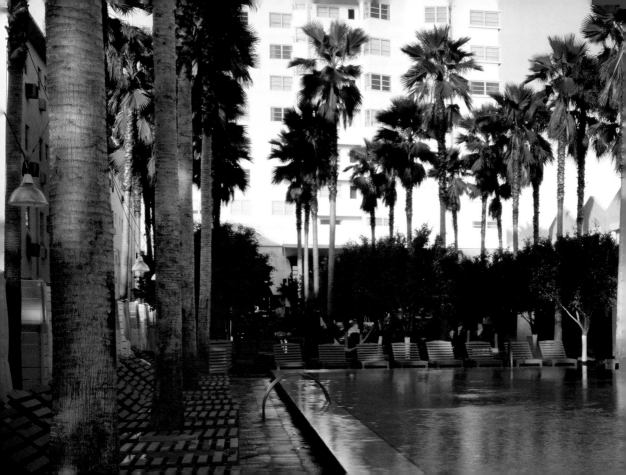

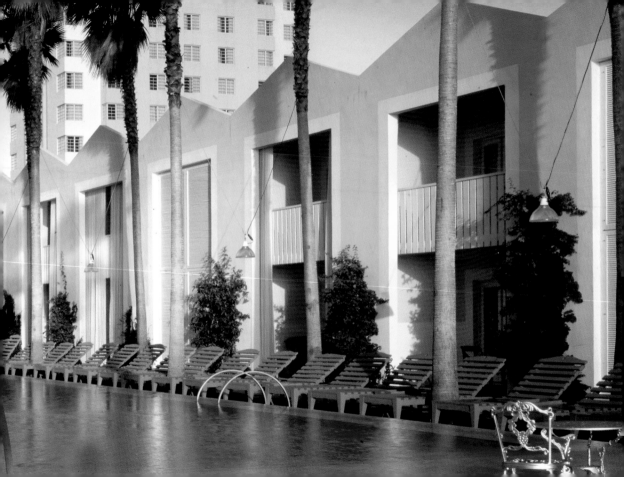

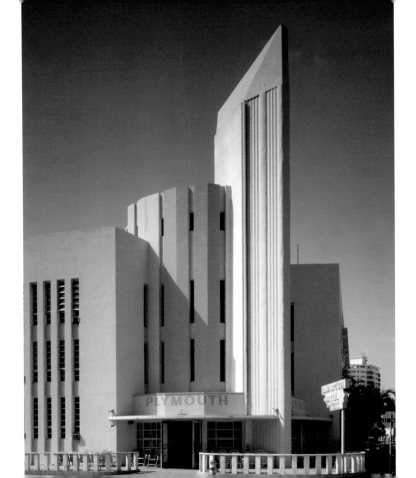

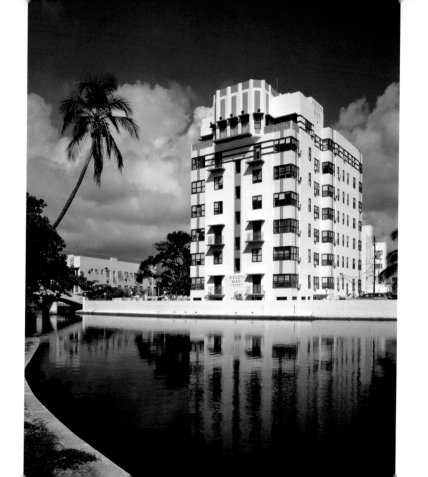

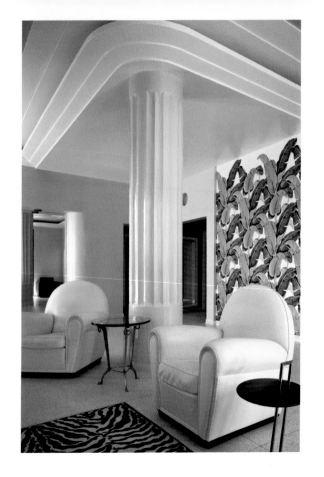

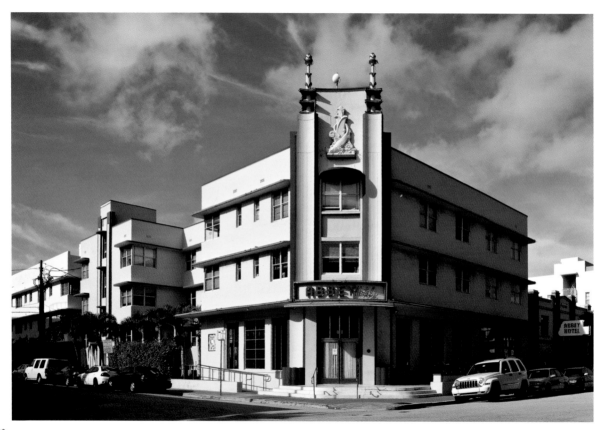

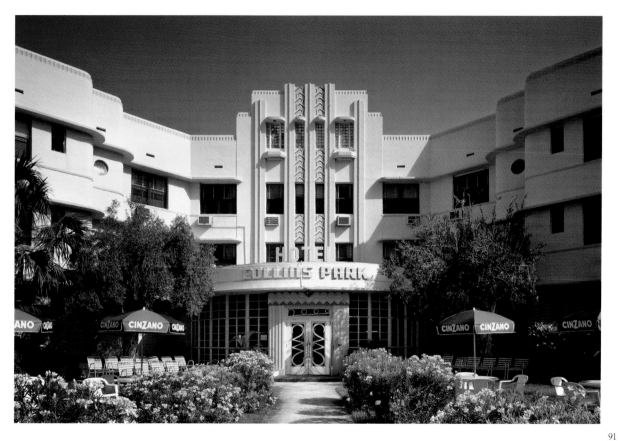

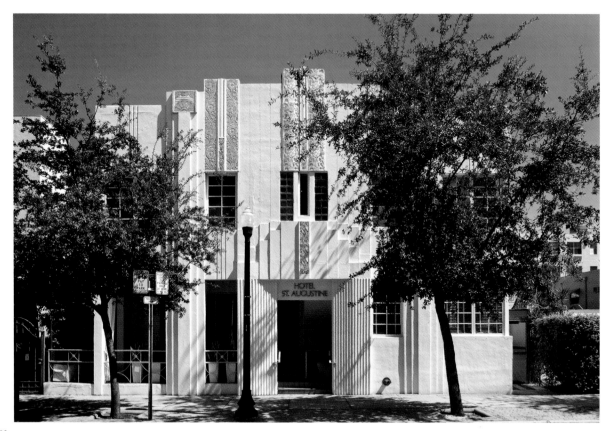

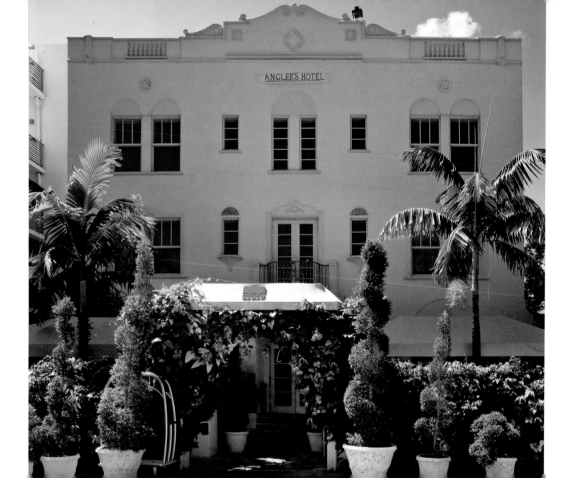

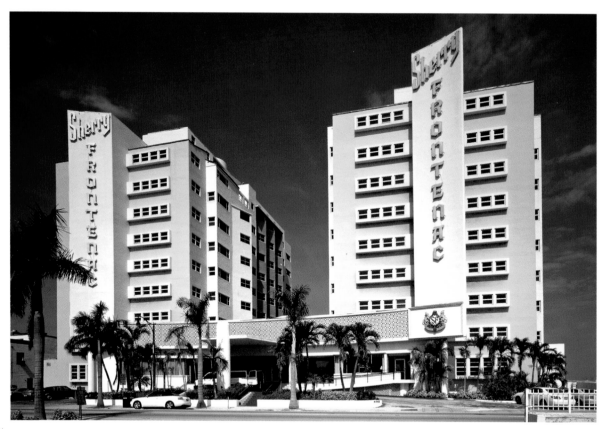

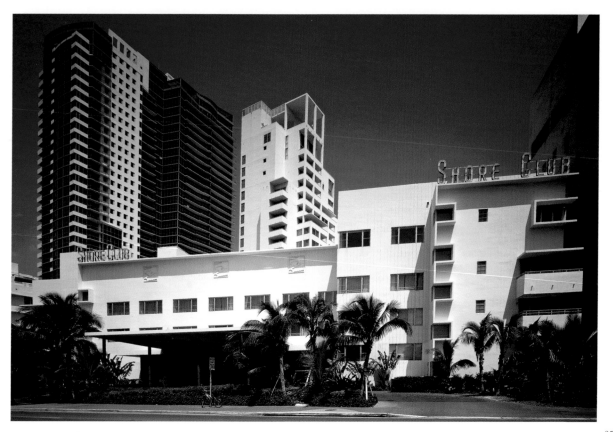

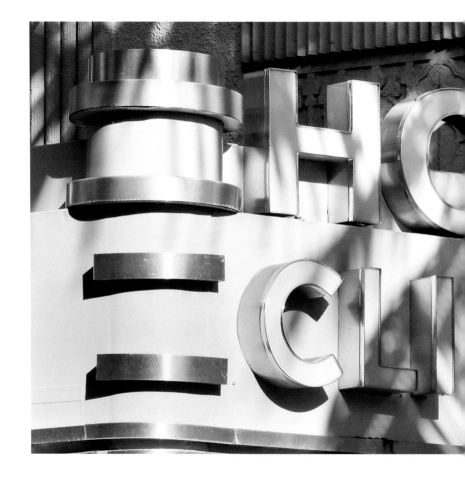

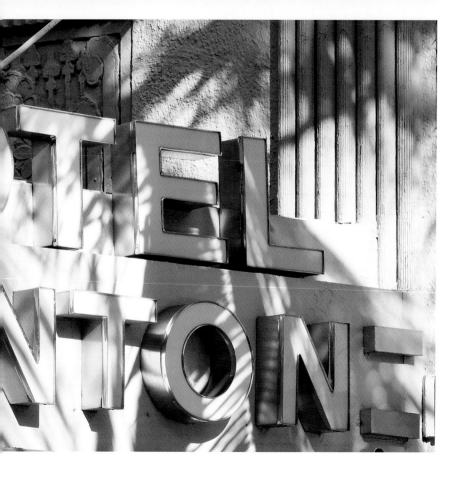

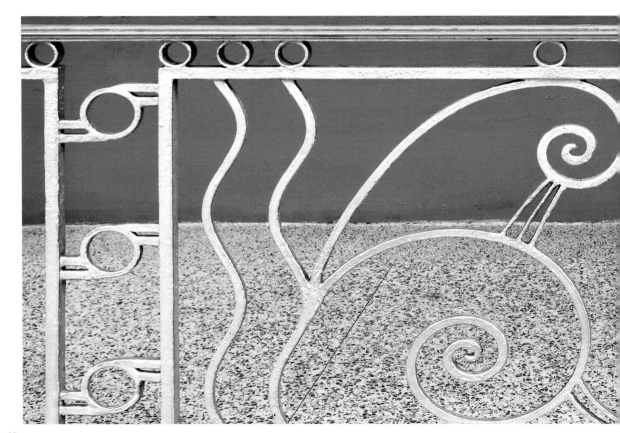

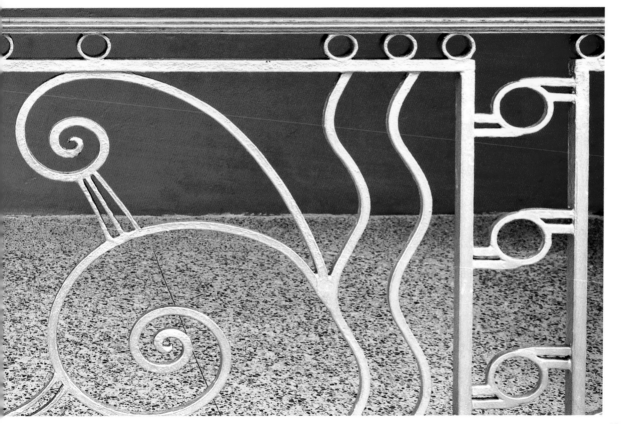

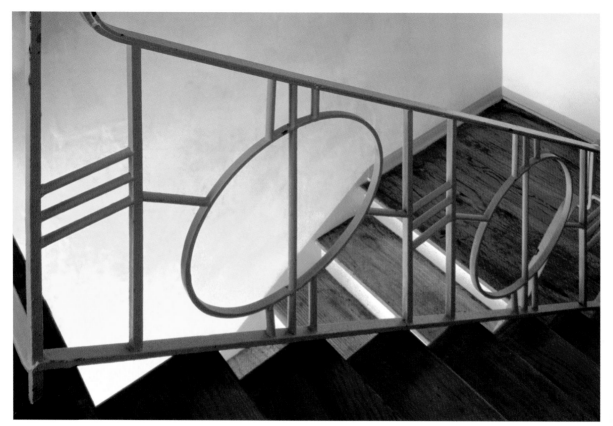

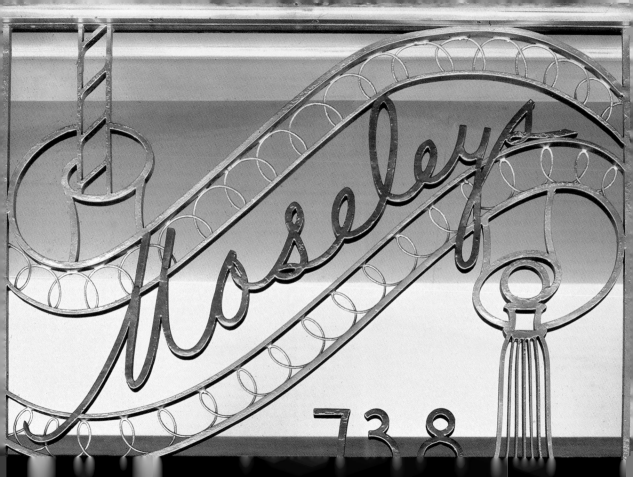

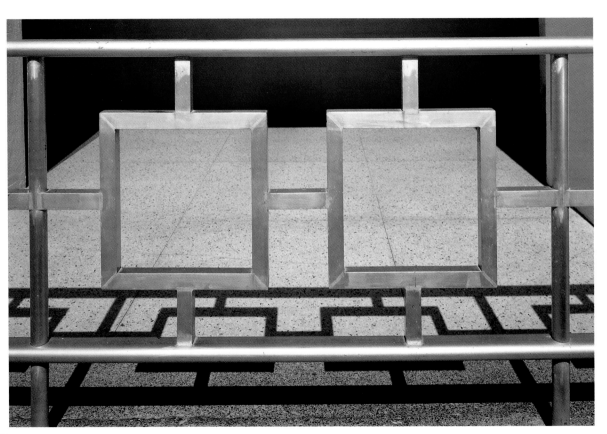

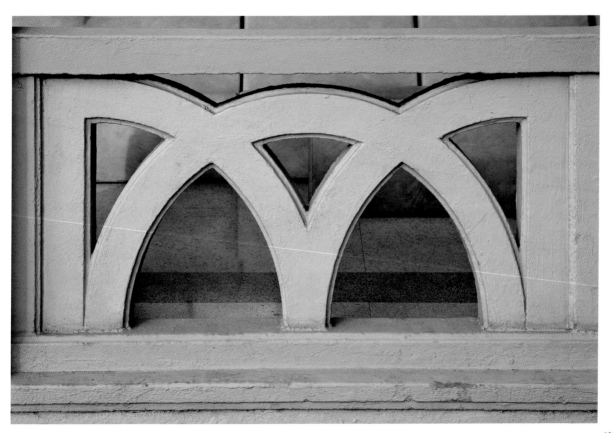

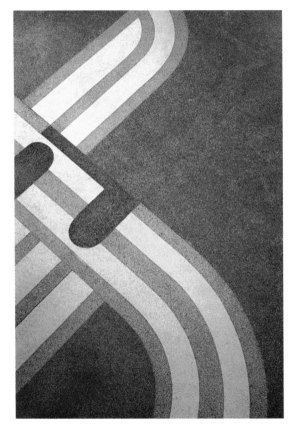
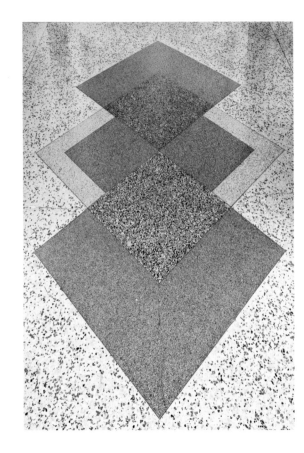

106

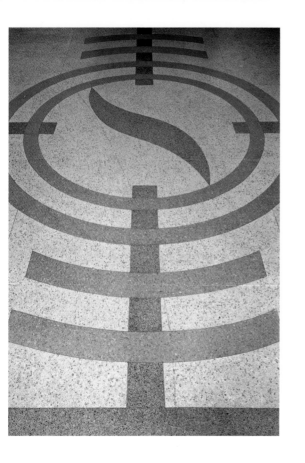
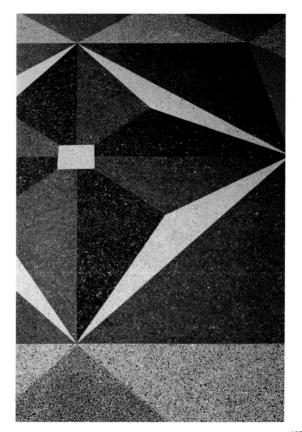

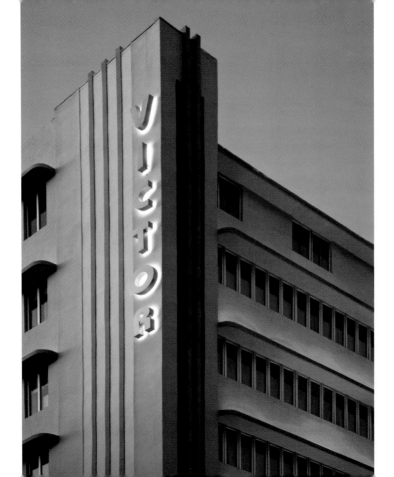

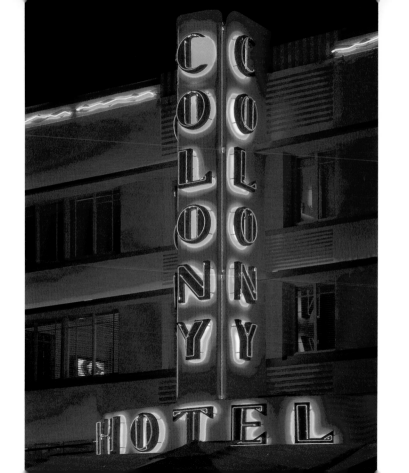

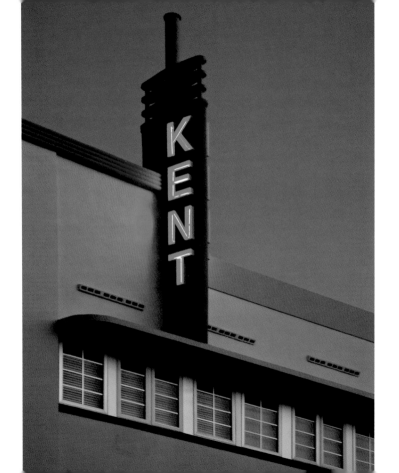

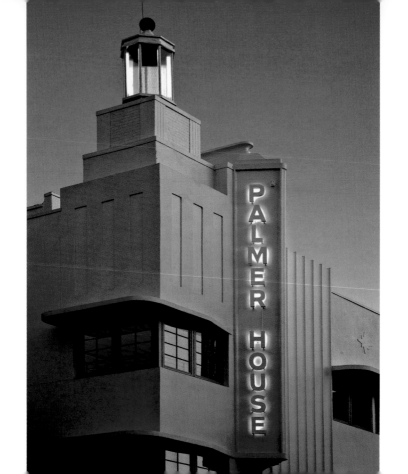

111

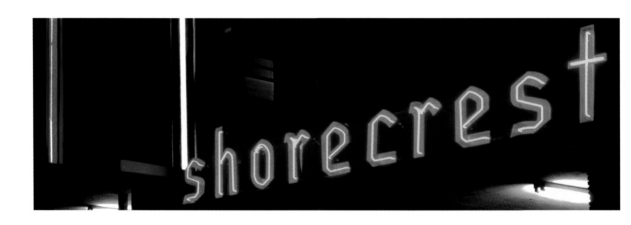

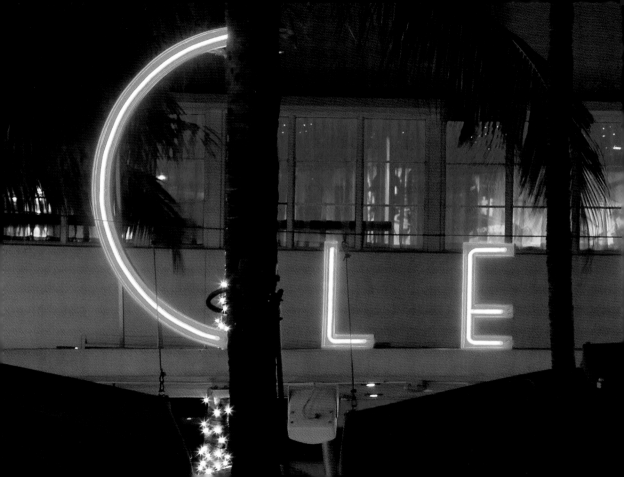

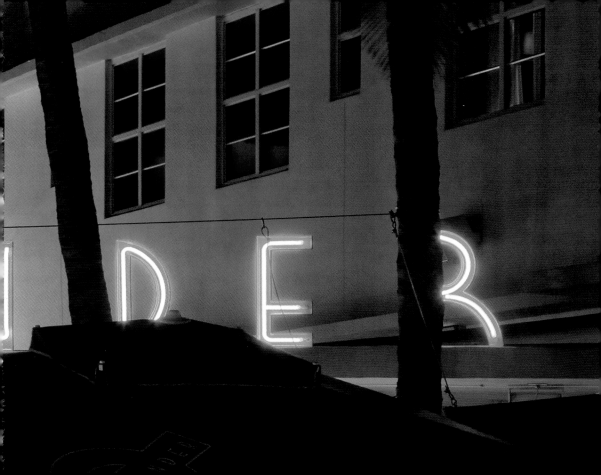

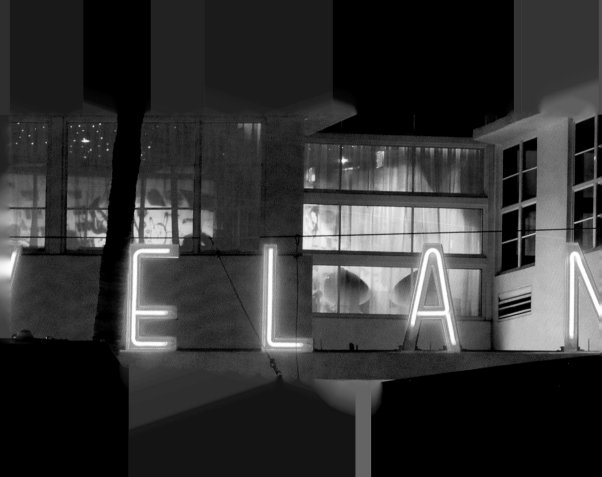

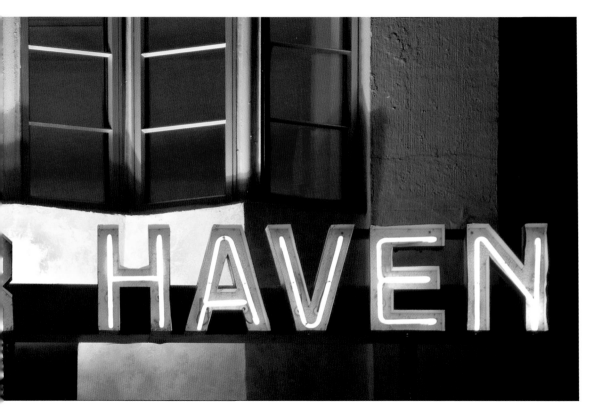

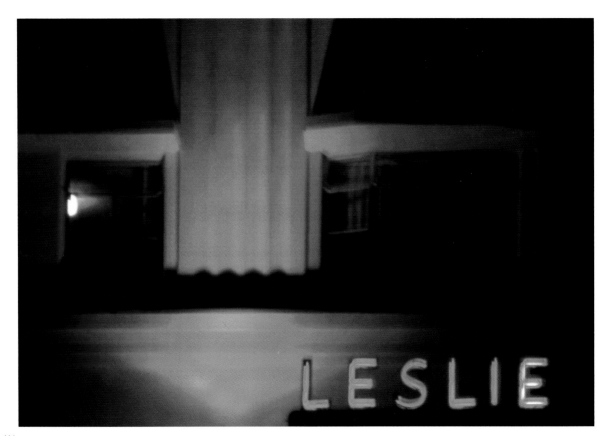

BREAKWATER

Parisian

Adrian

BARBIZON

BANCROFT

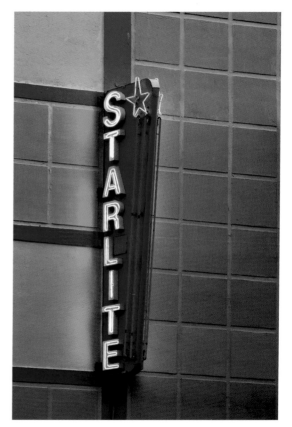

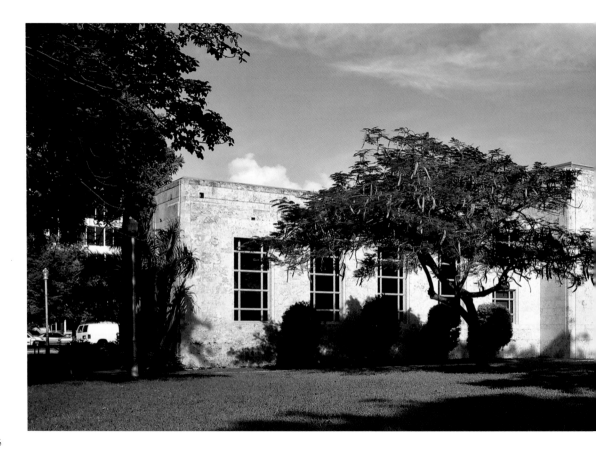

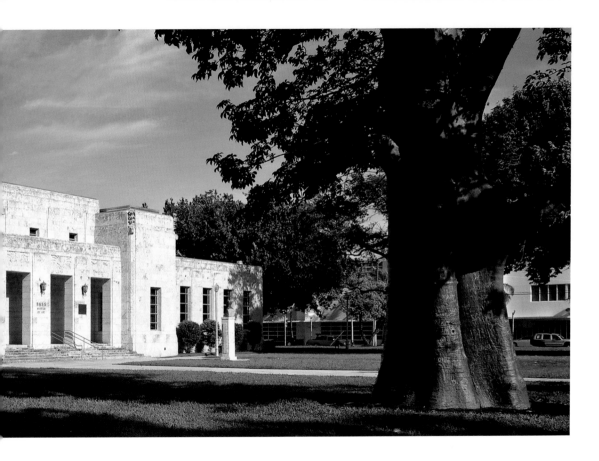

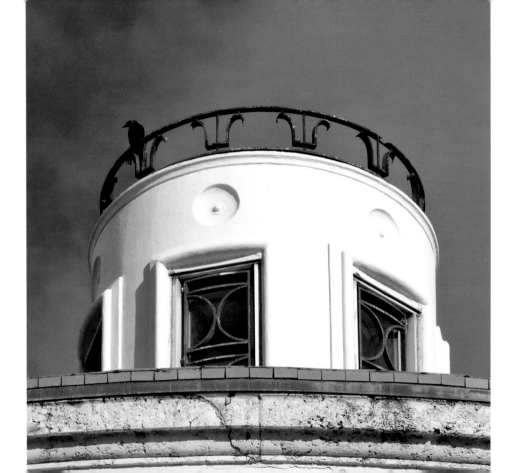

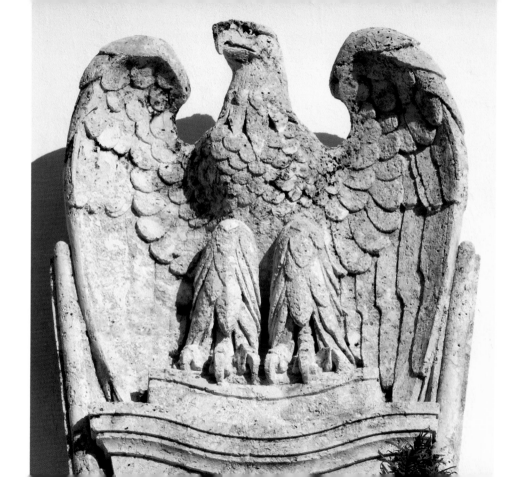

119

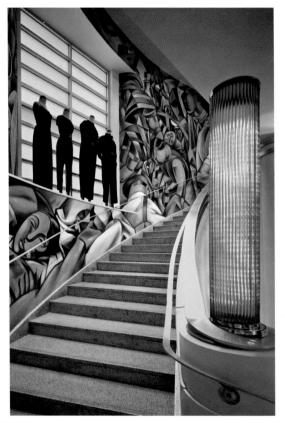

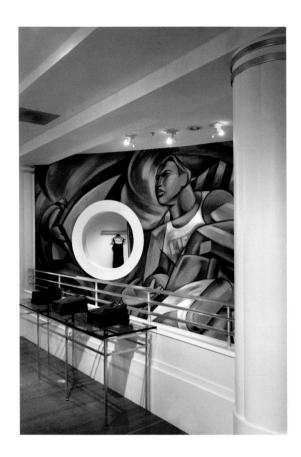

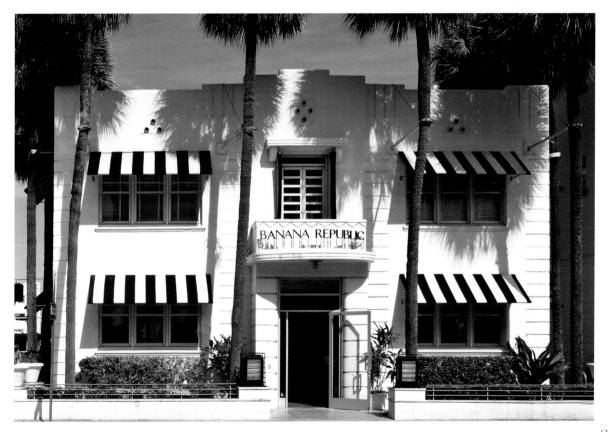

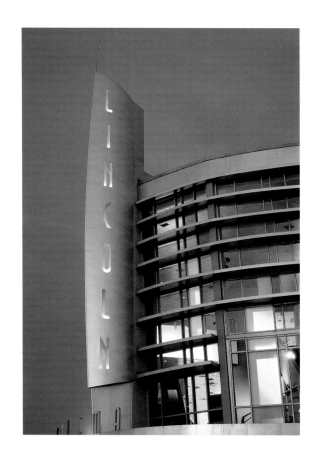

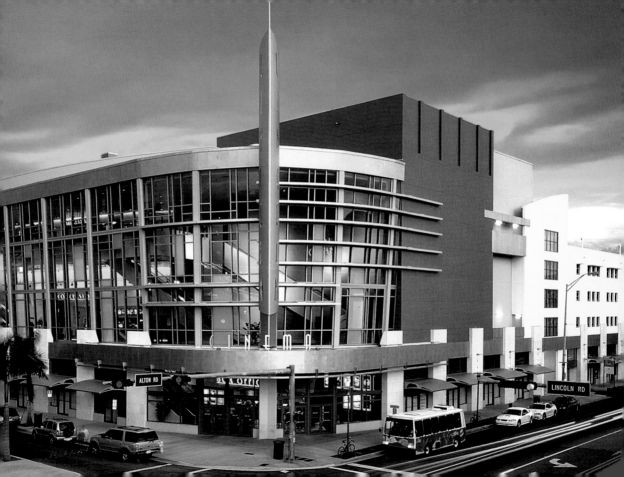

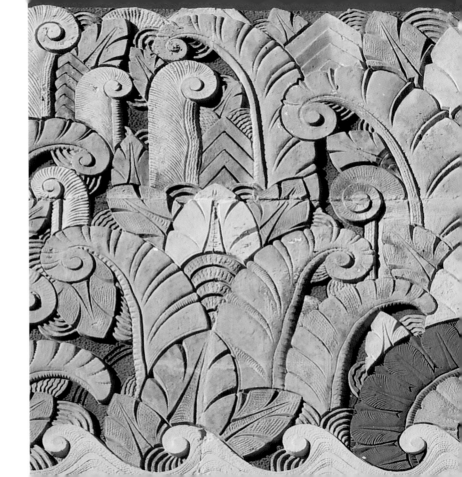

124

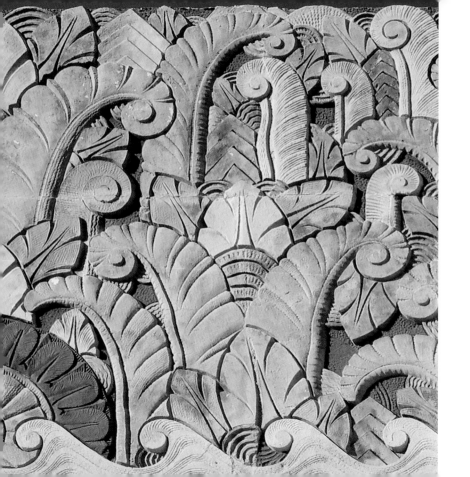

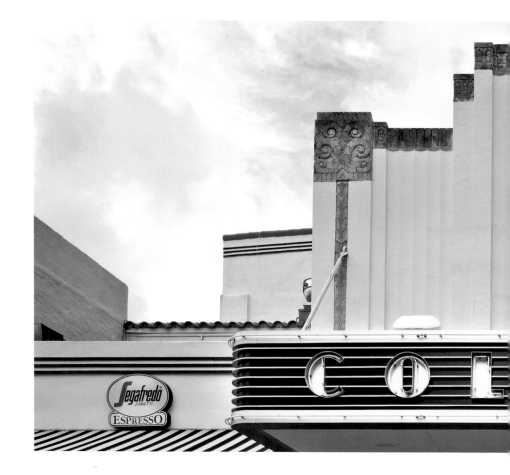

126

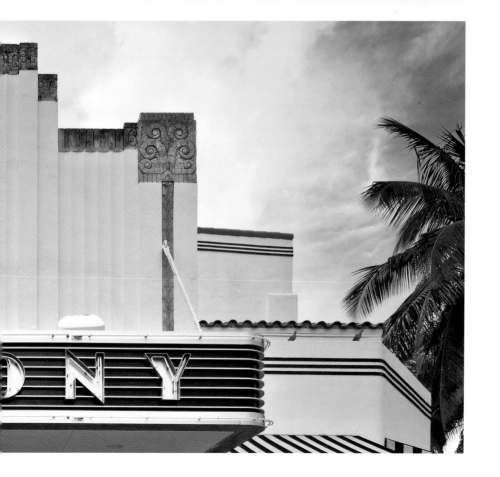

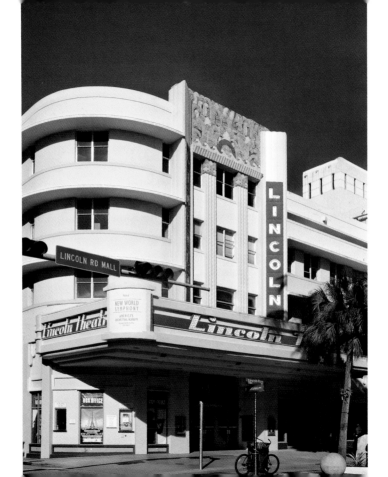

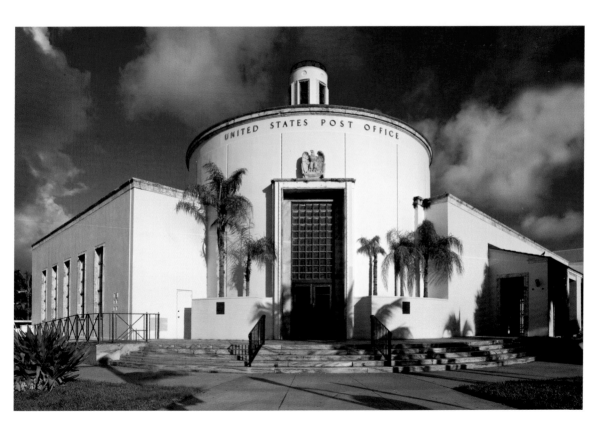

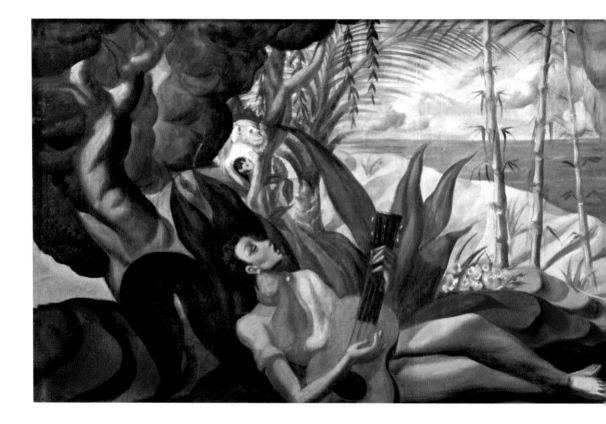

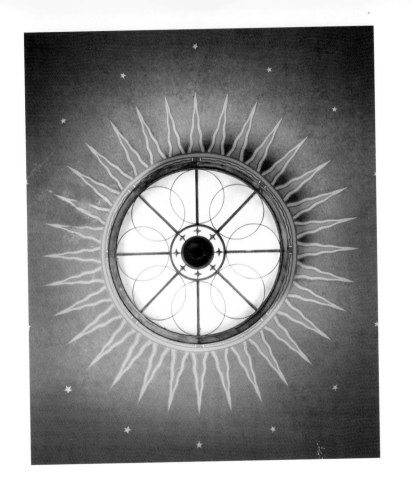

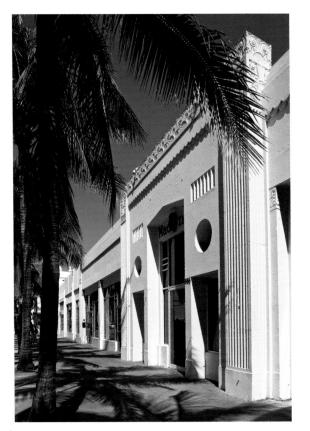
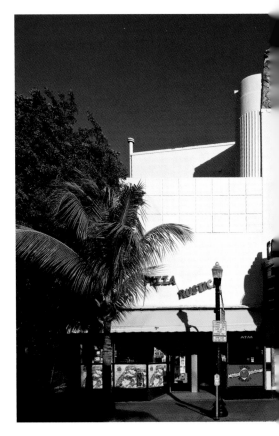

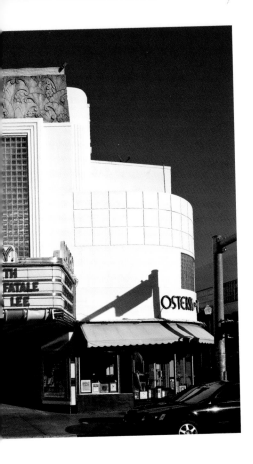
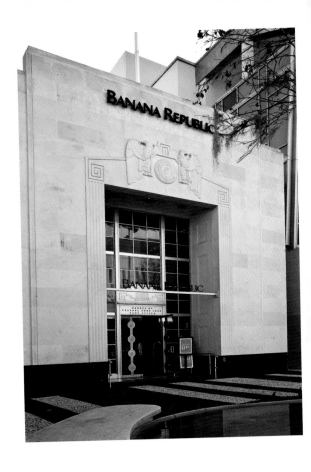

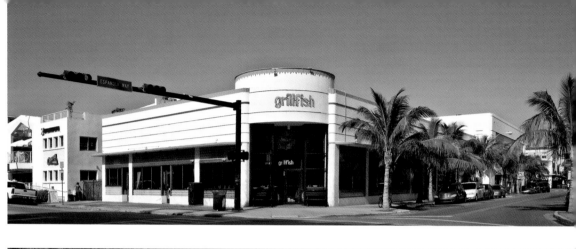

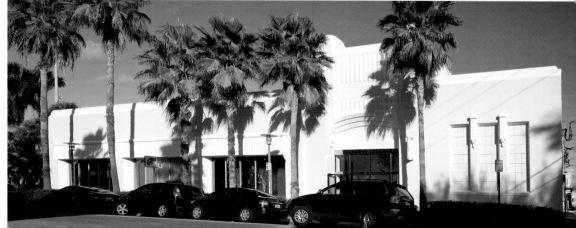

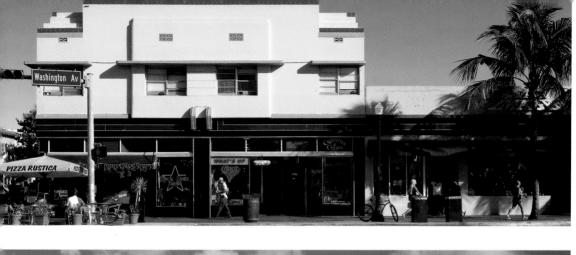

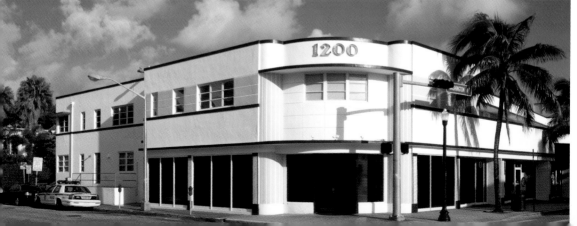

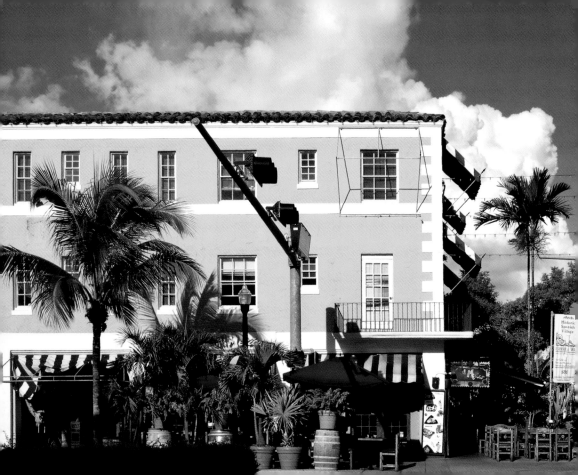

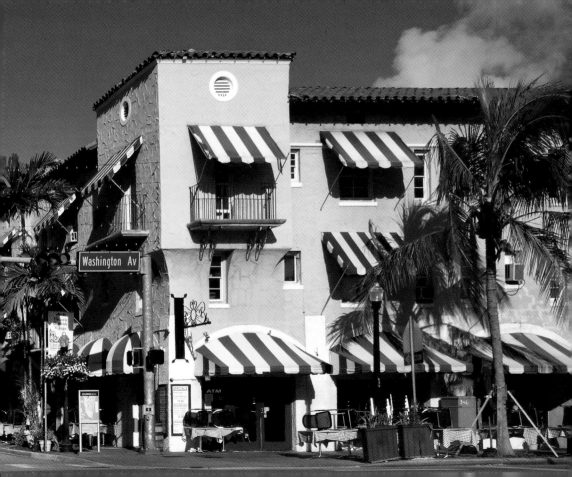

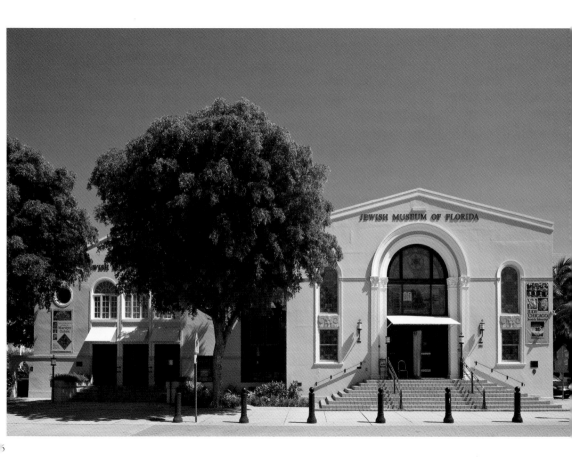

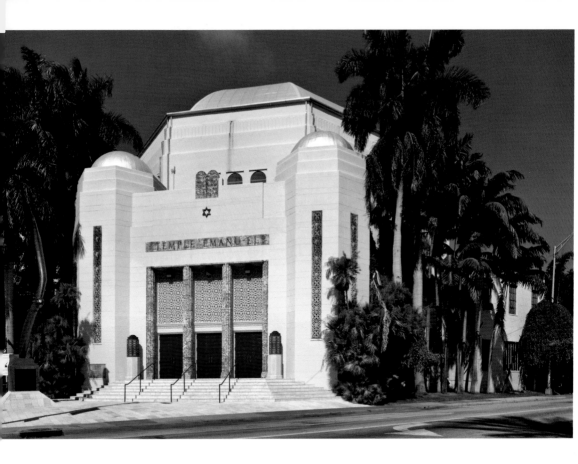

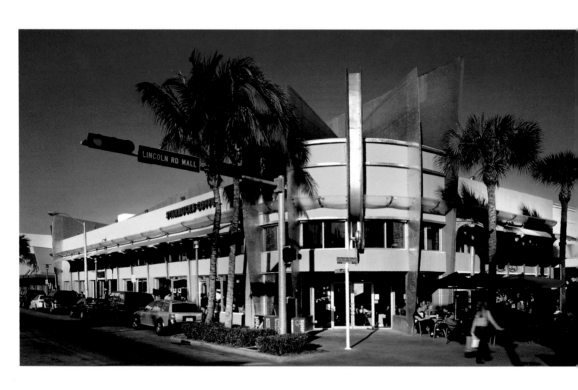

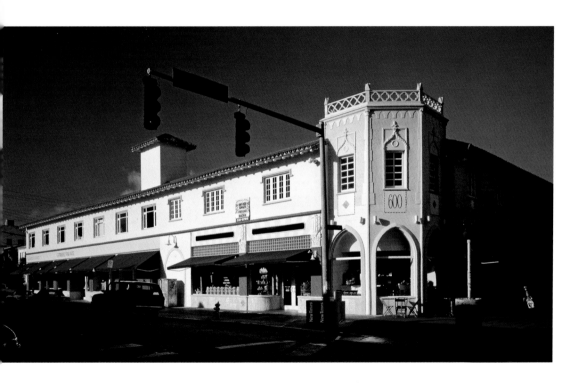

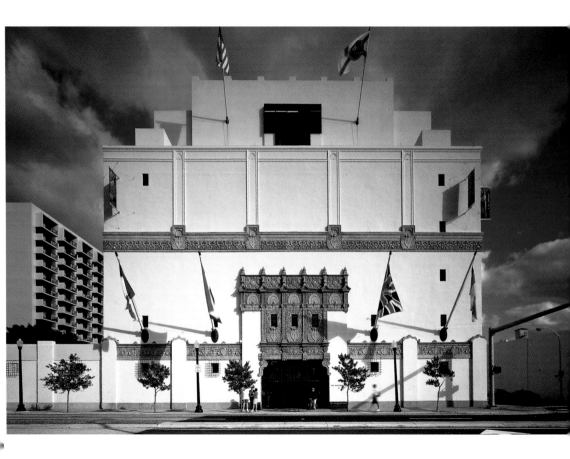

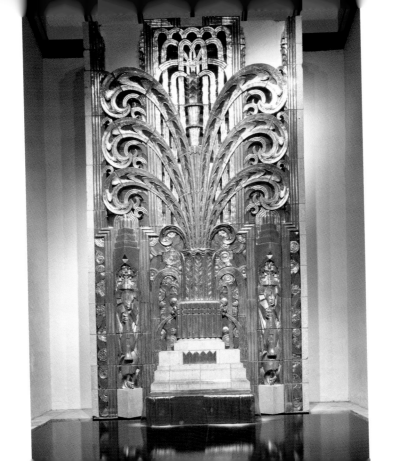

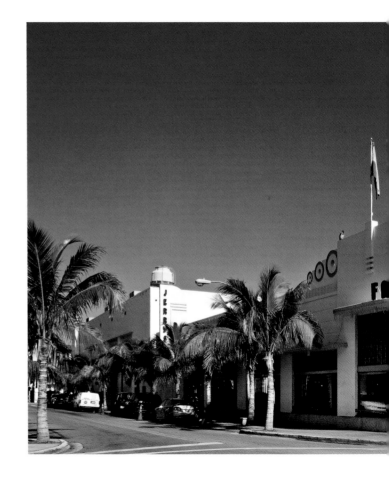

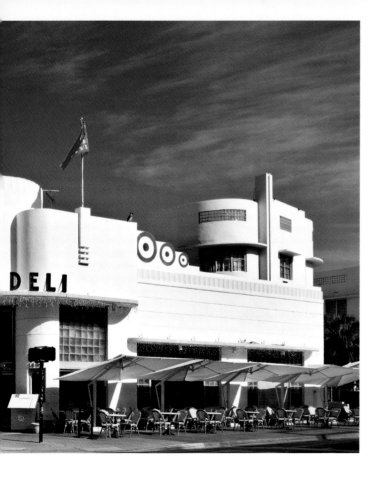

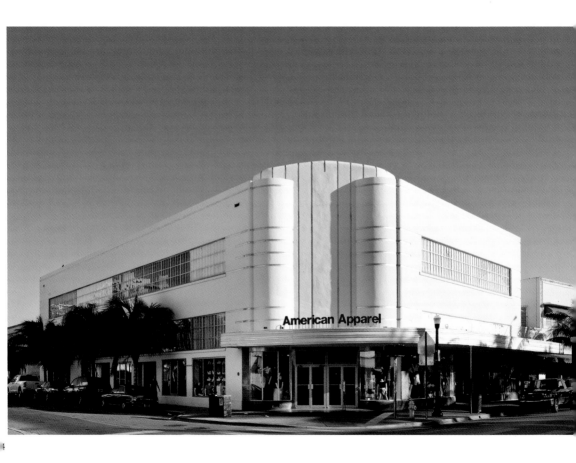

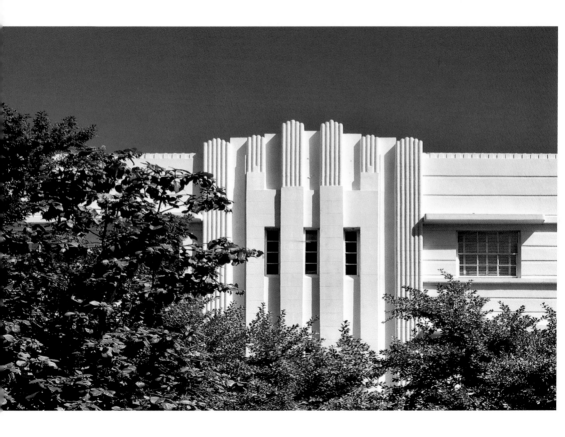

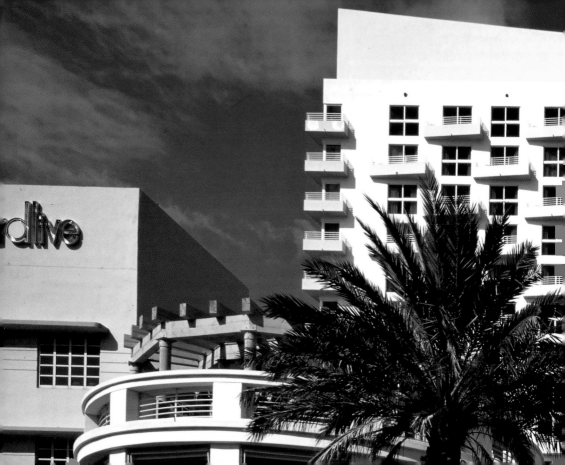

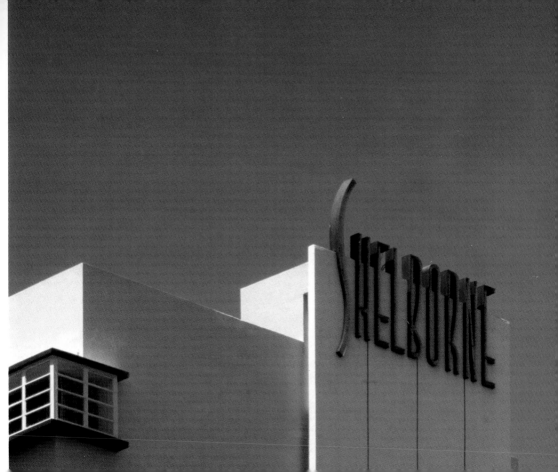

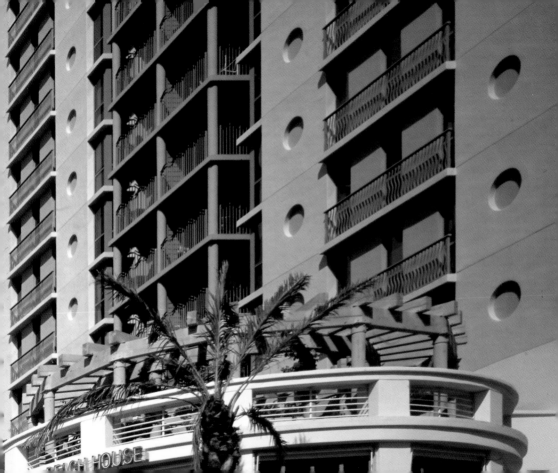

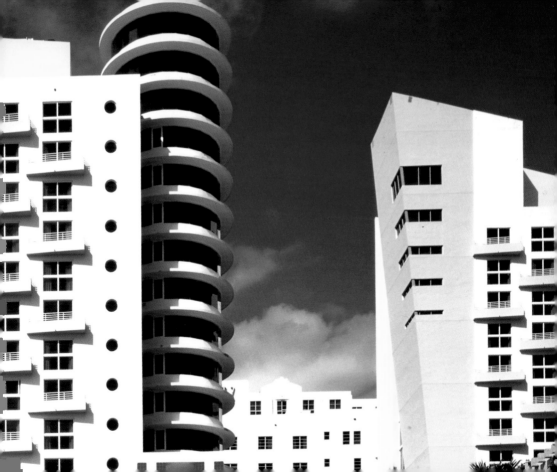

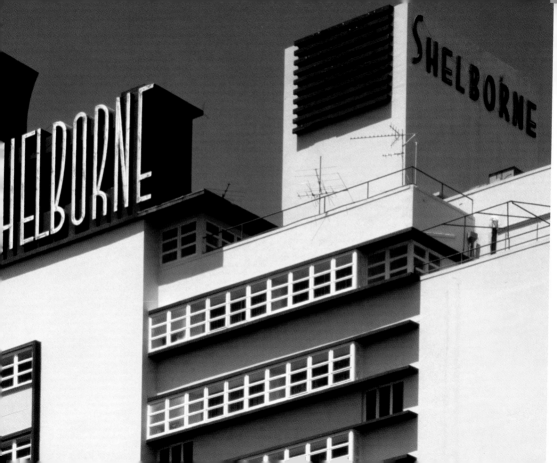

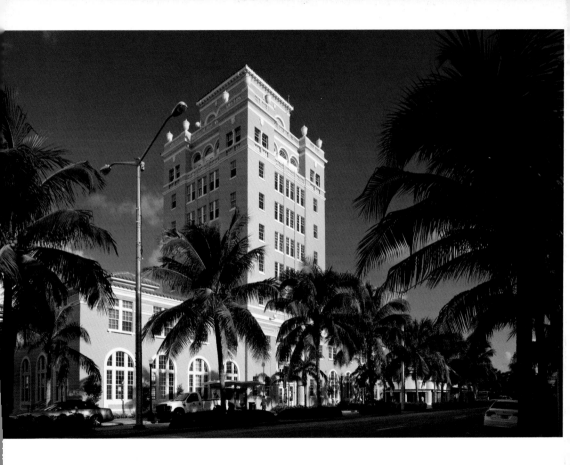

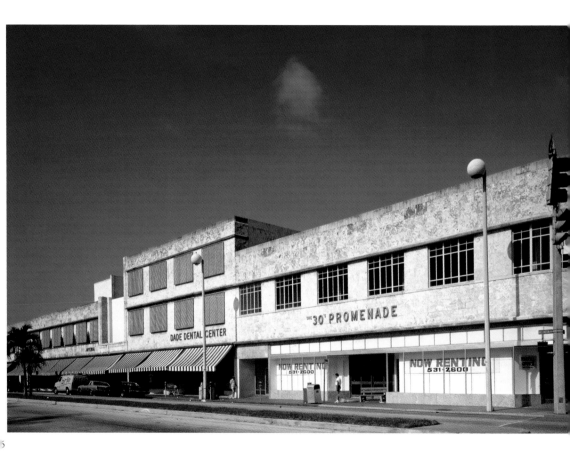

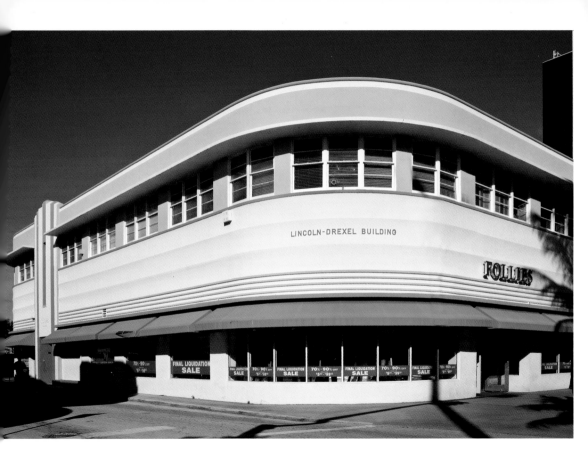

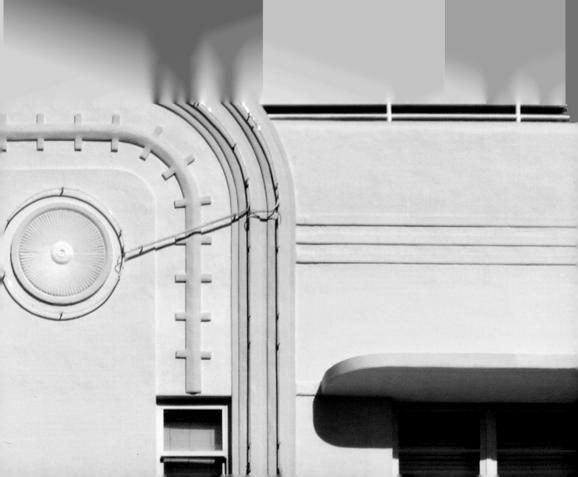

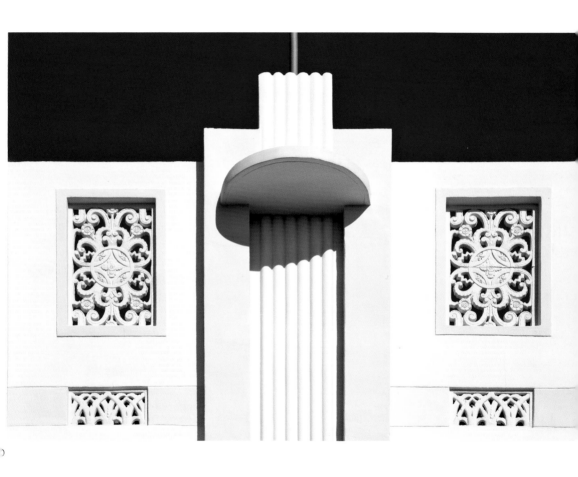

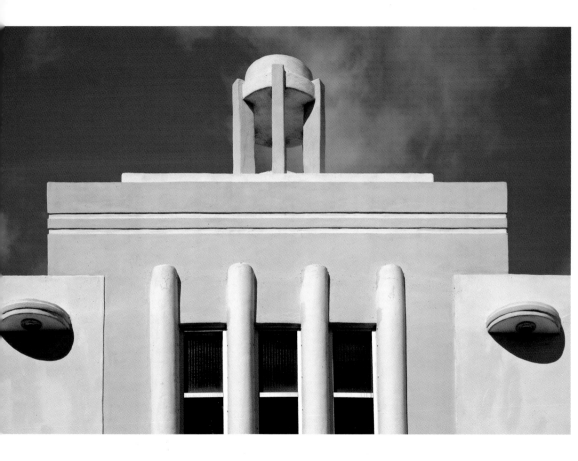

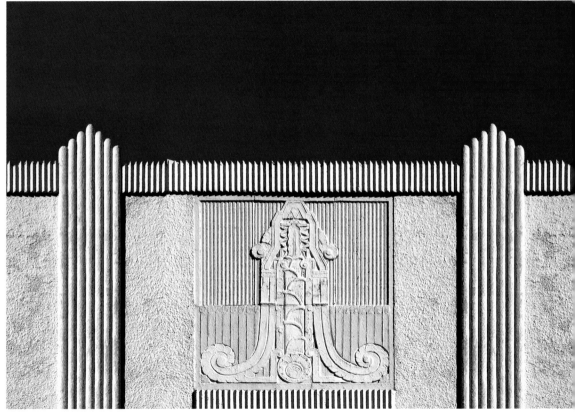

2

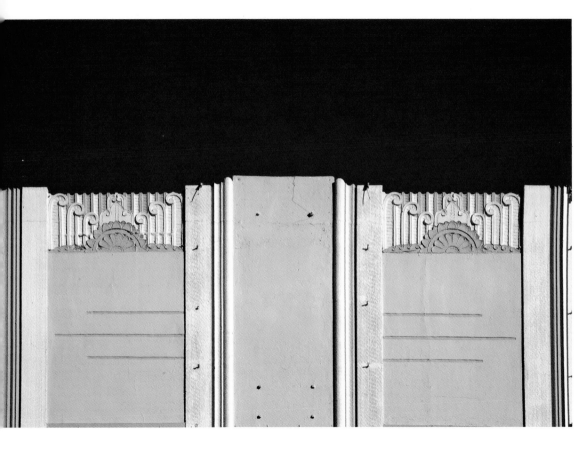

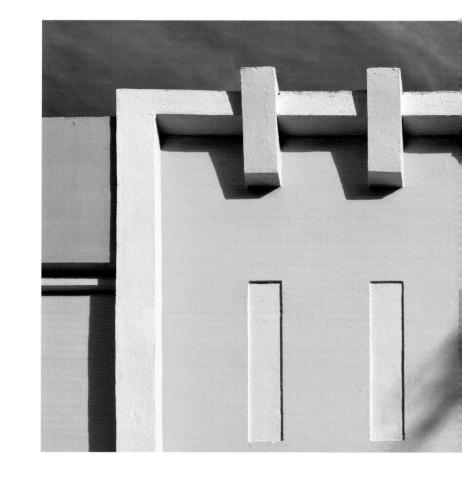

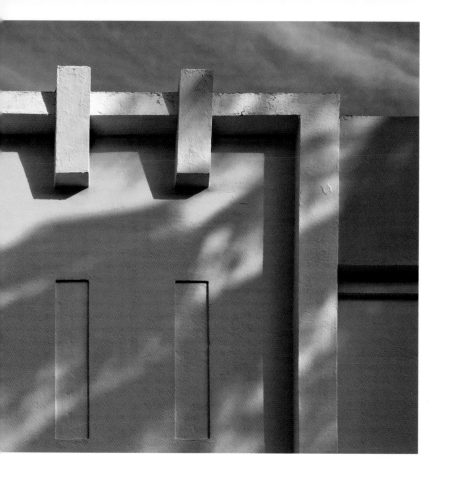

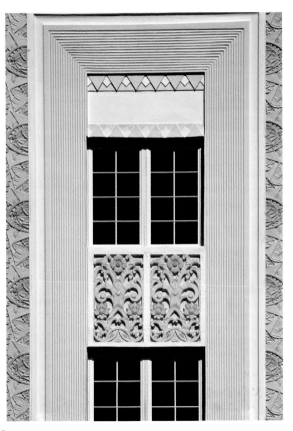
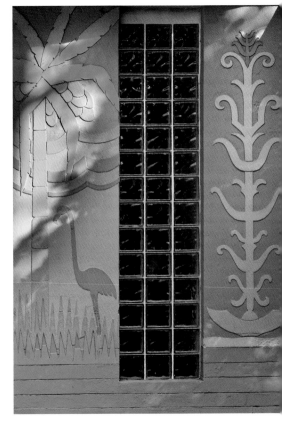

6

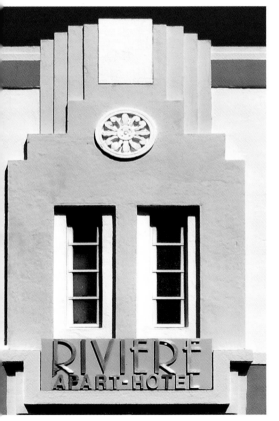
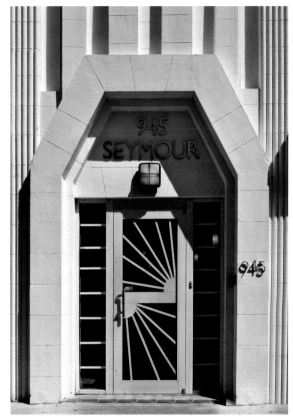

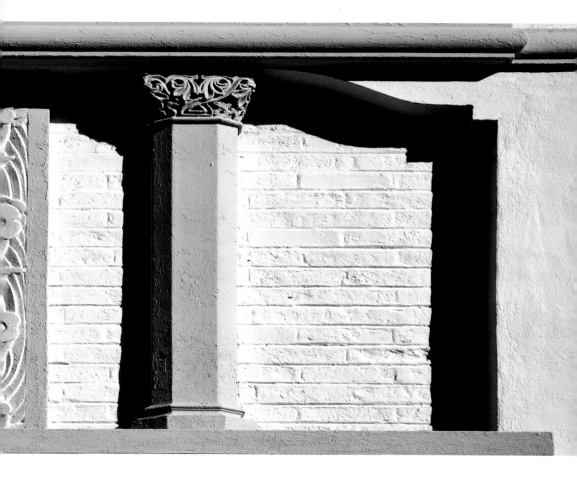

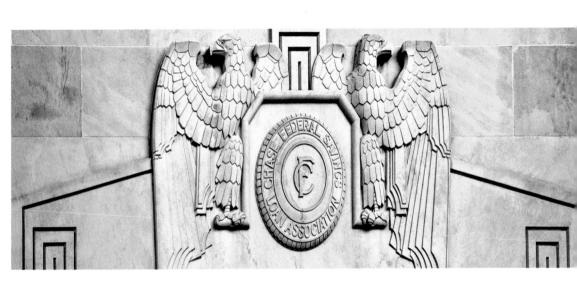

CHASE FEDERAL SAVINGS
LOAN ASSOCIATION

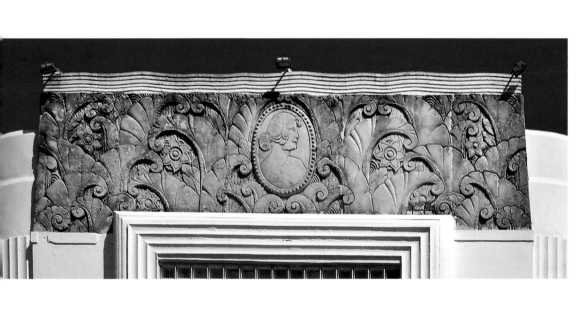

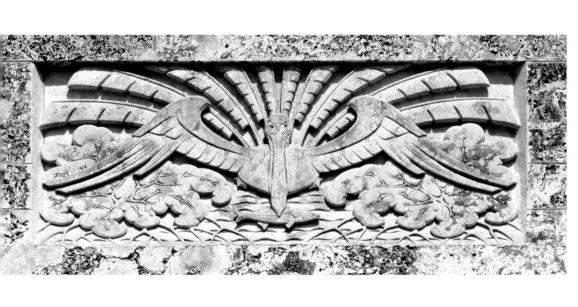

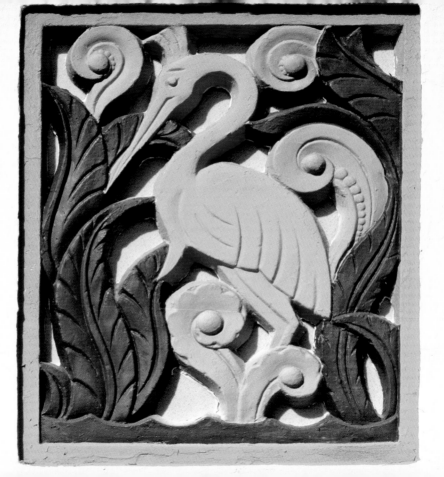

4

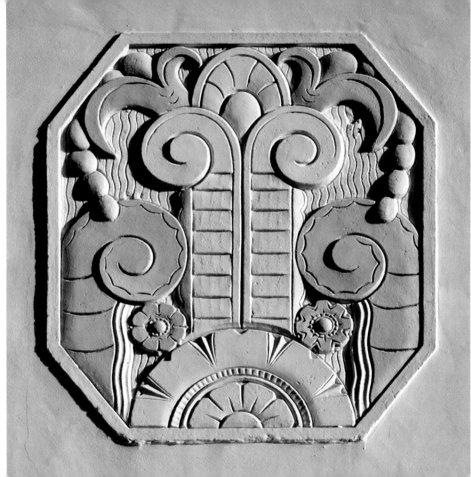

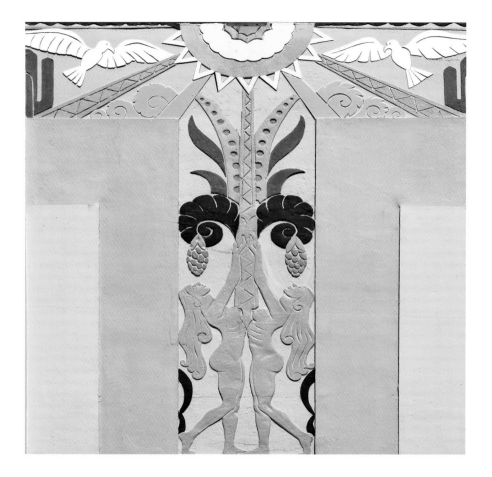

6

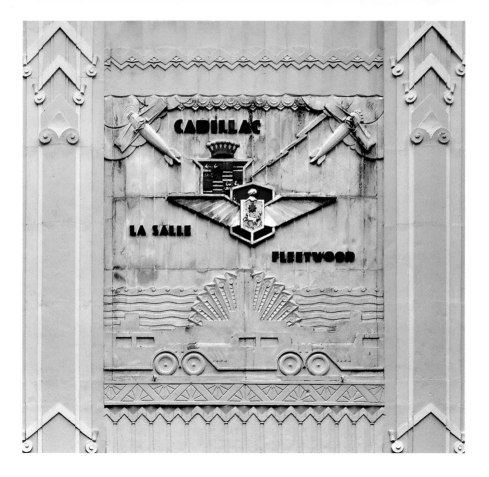

8

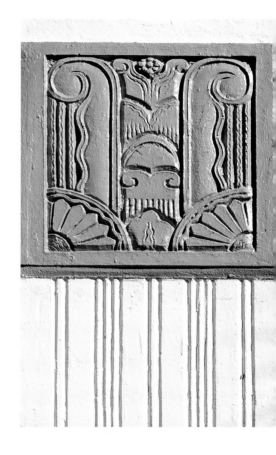

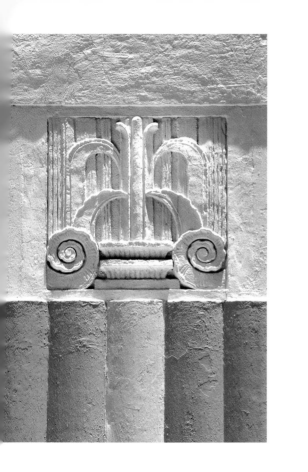
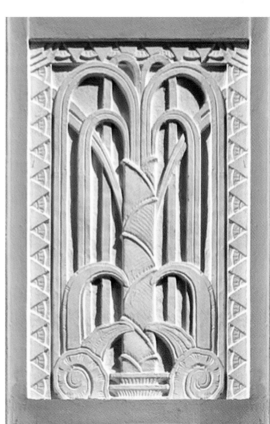

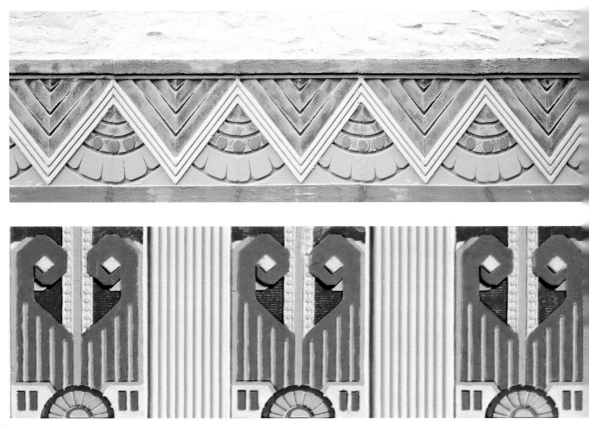

2

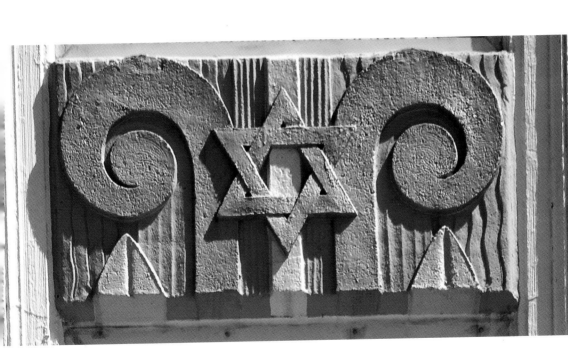

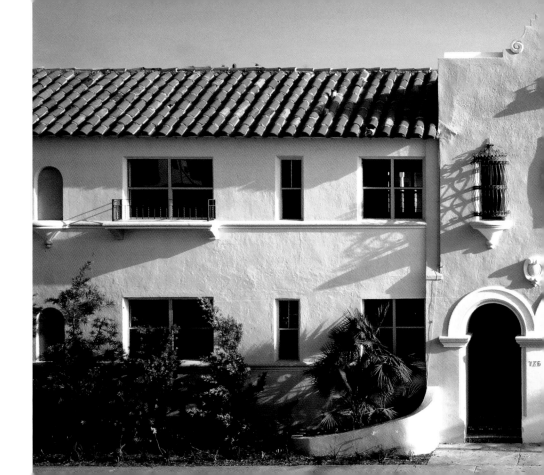

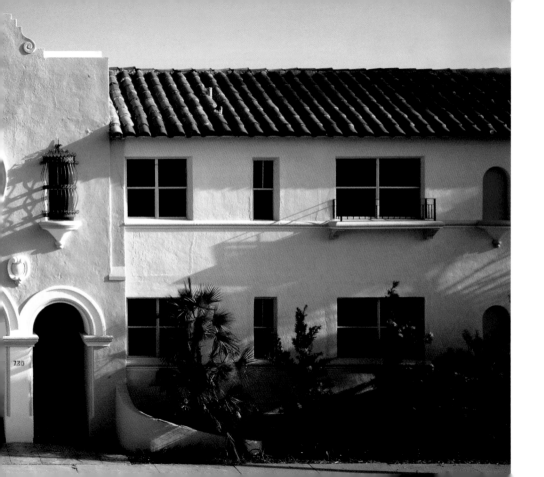

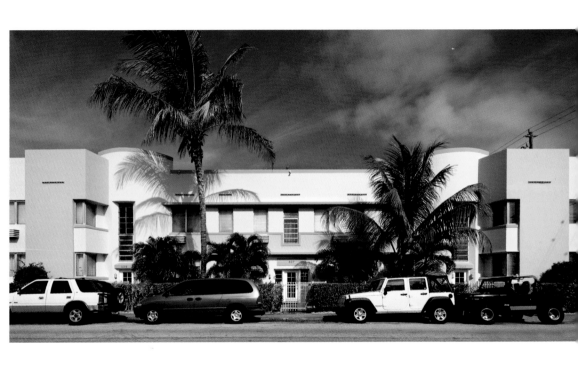

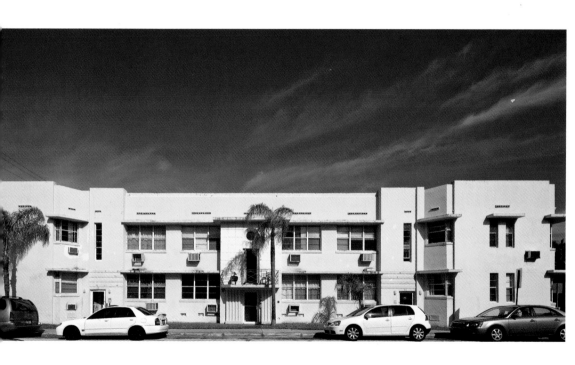

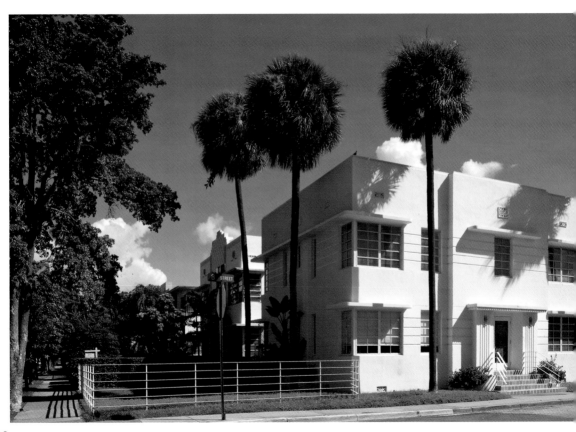

8

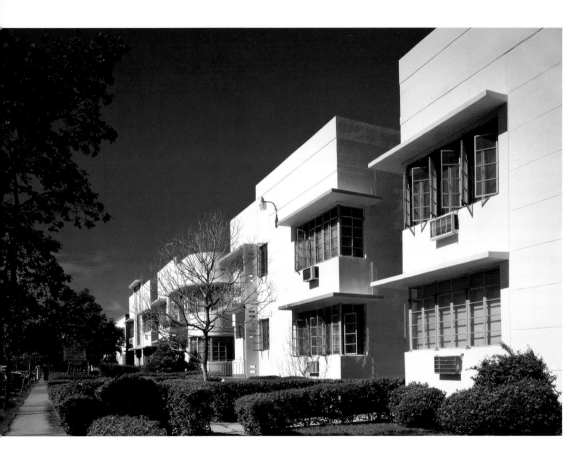

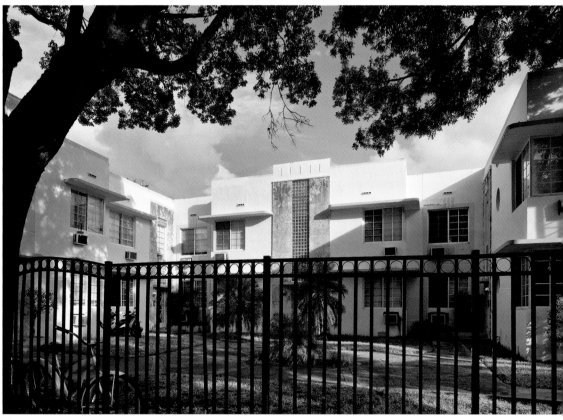

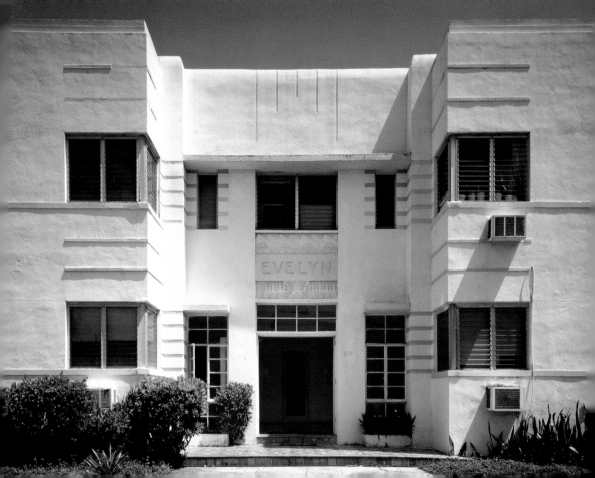

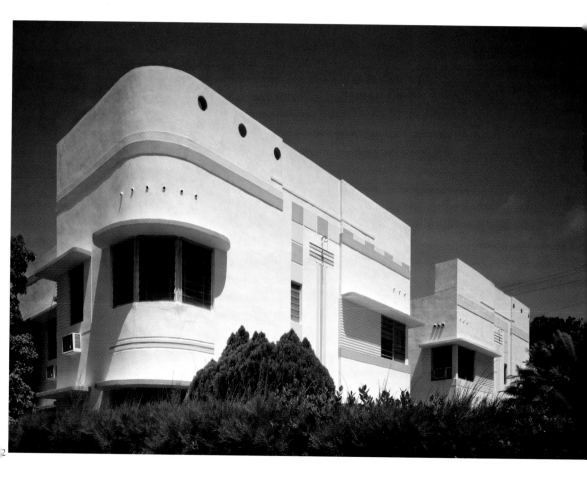

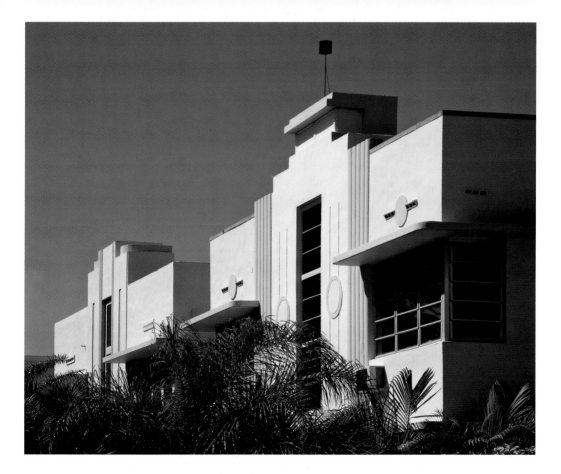

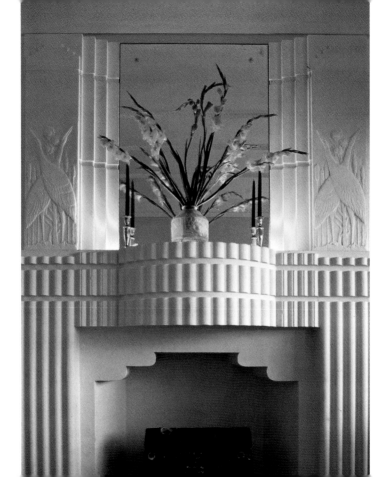

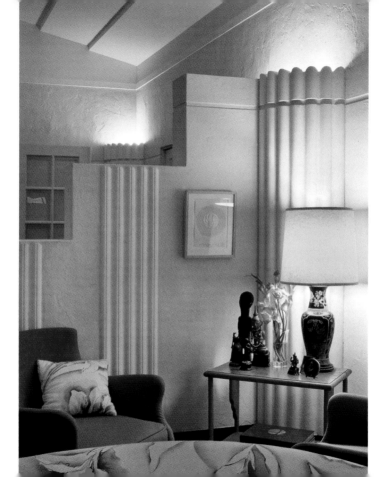

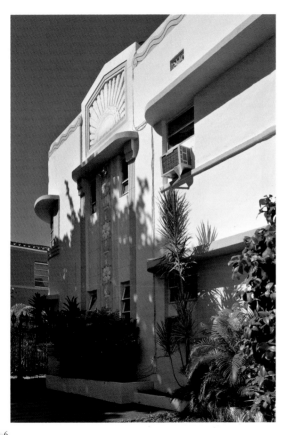
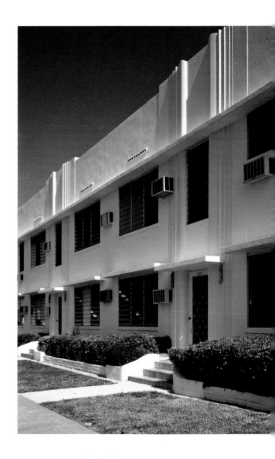

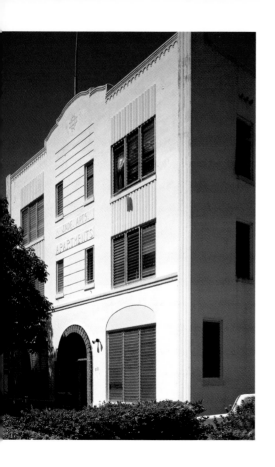
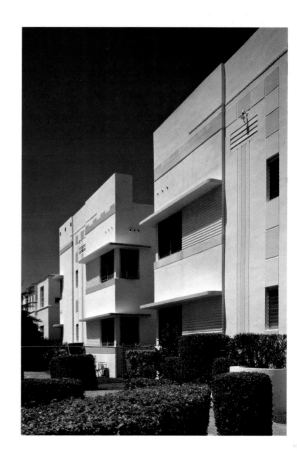

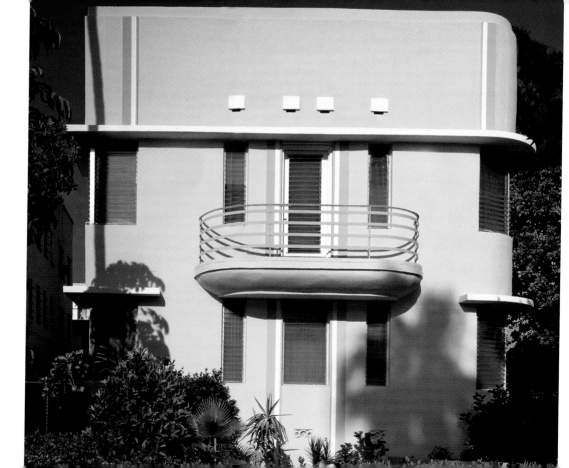

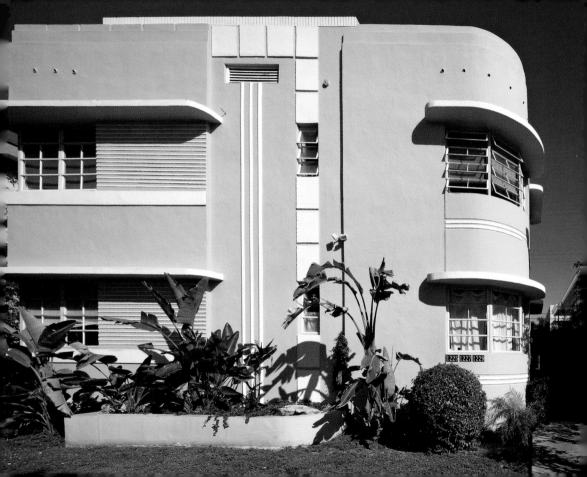

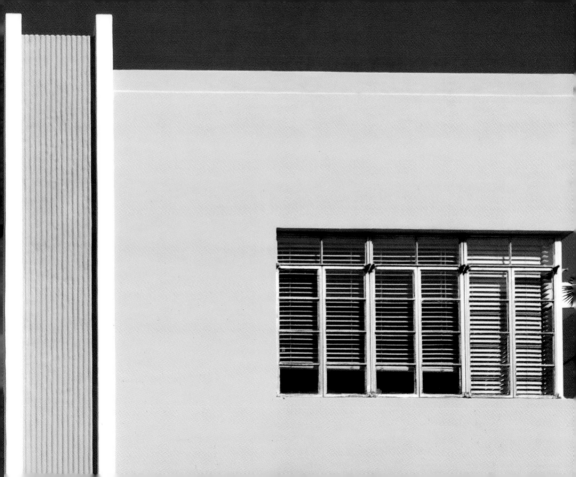

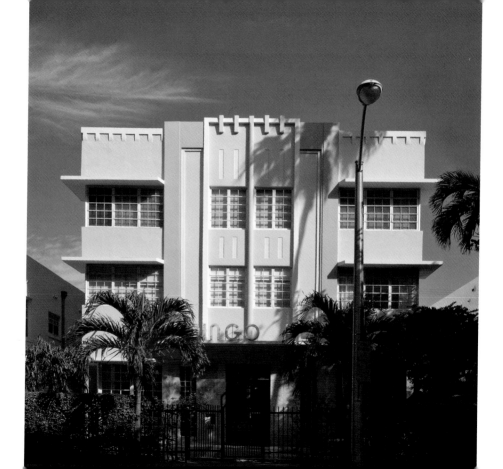

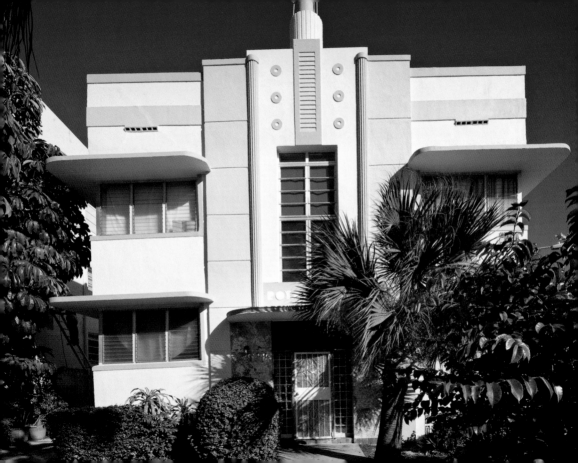

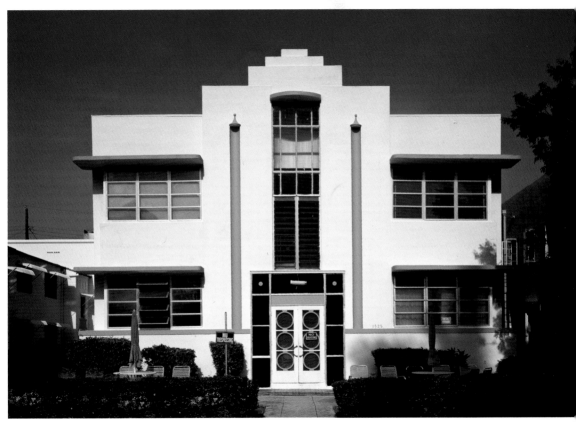

4

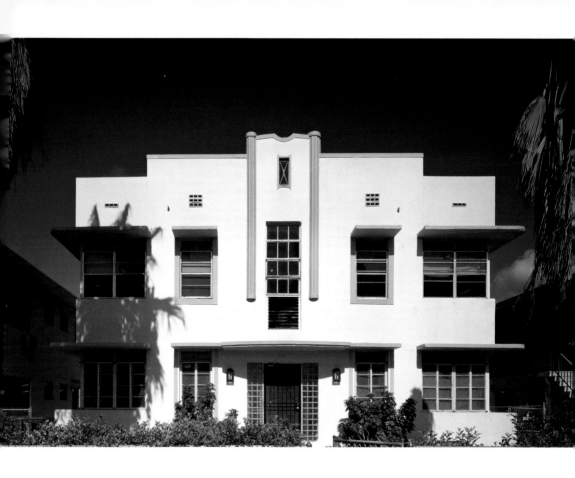

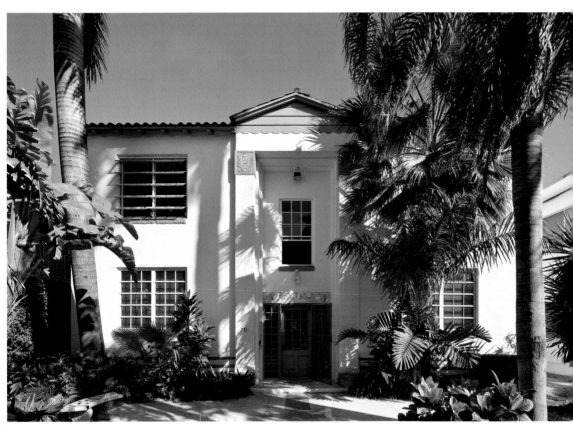

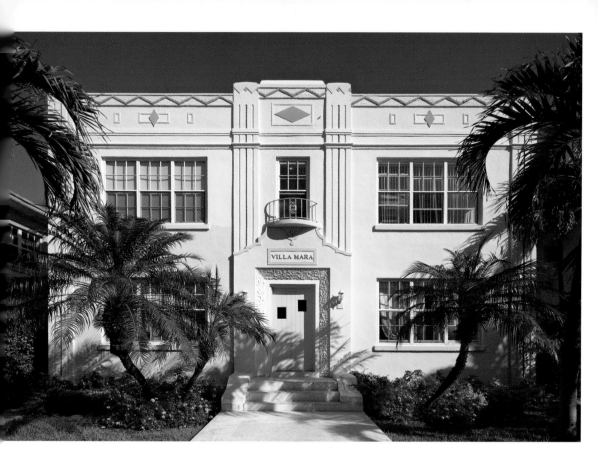

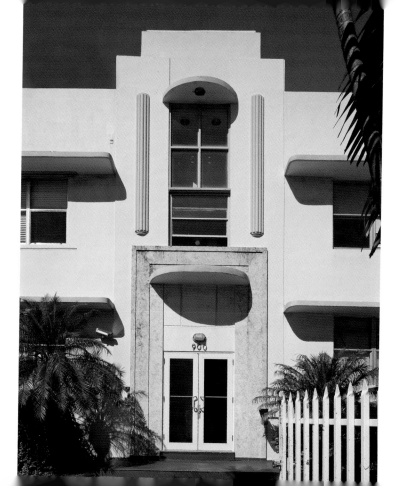

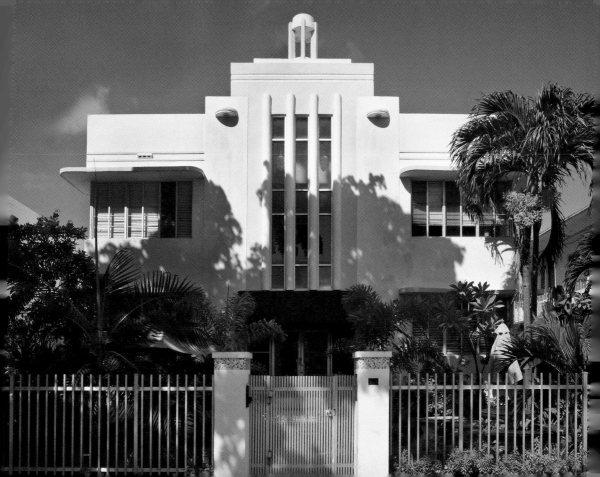

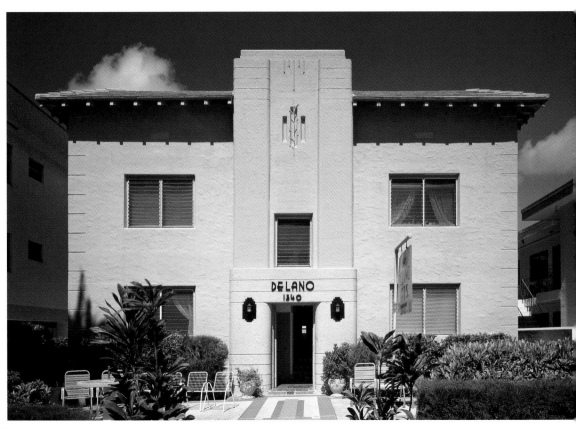

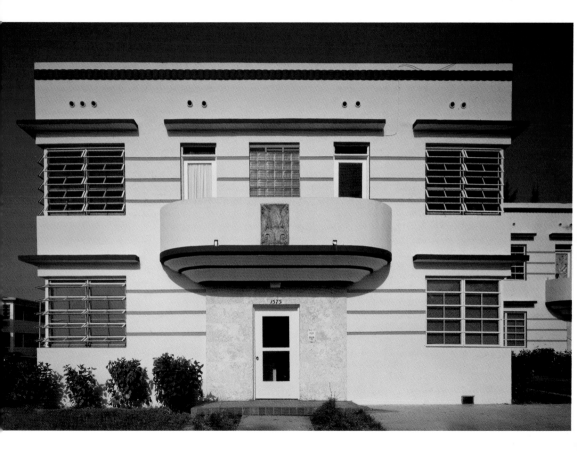

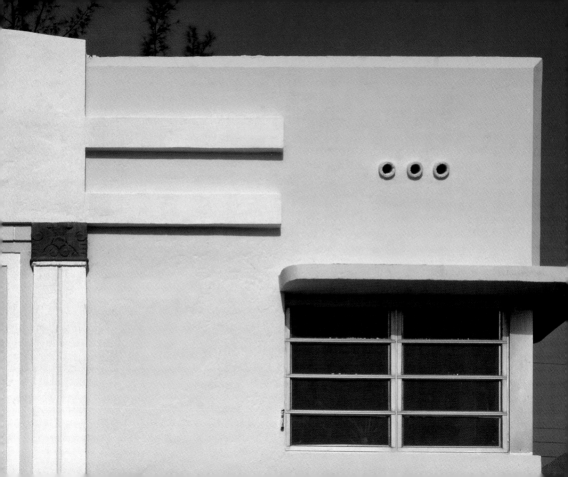

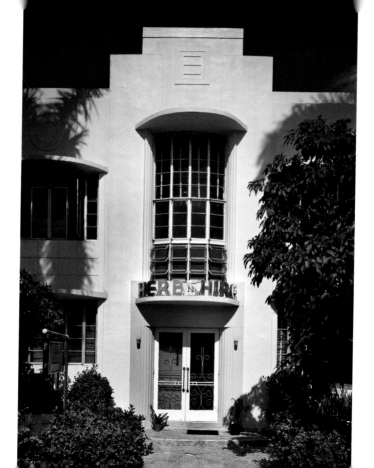

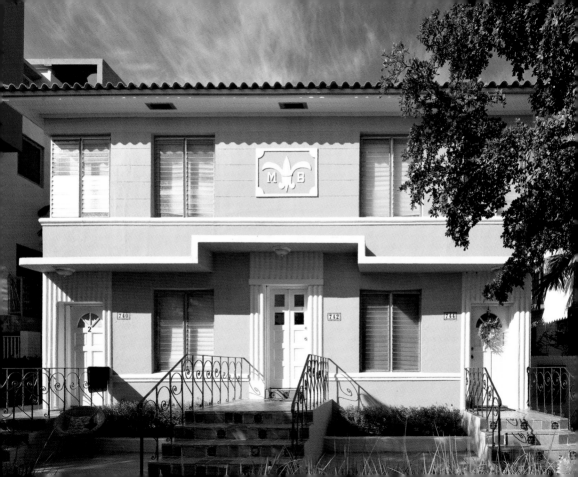

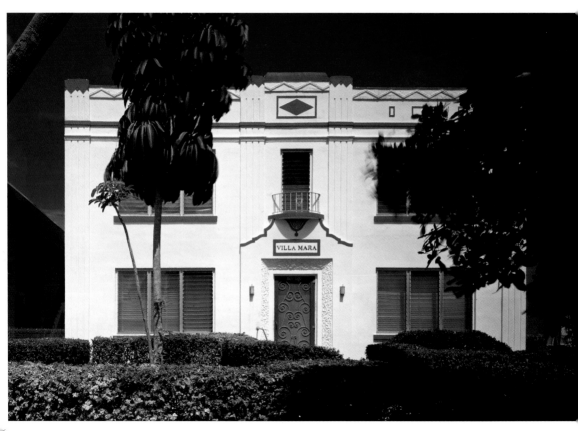

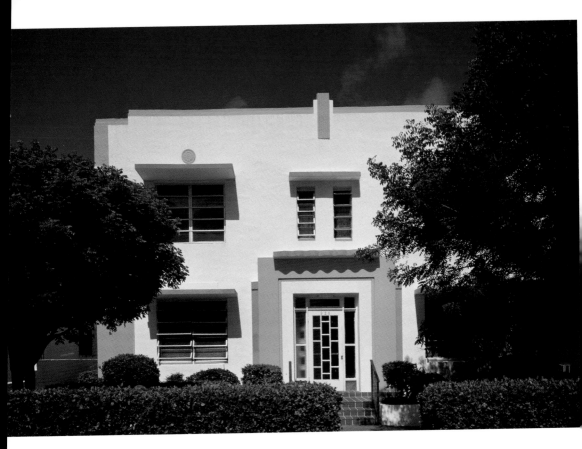

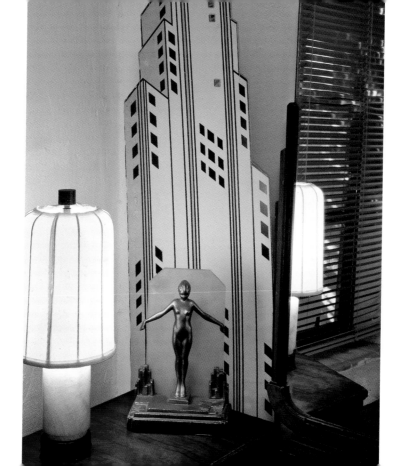

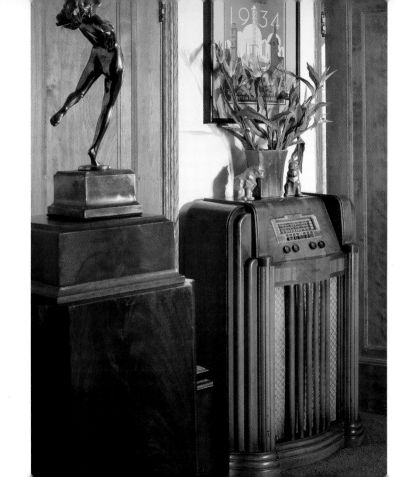

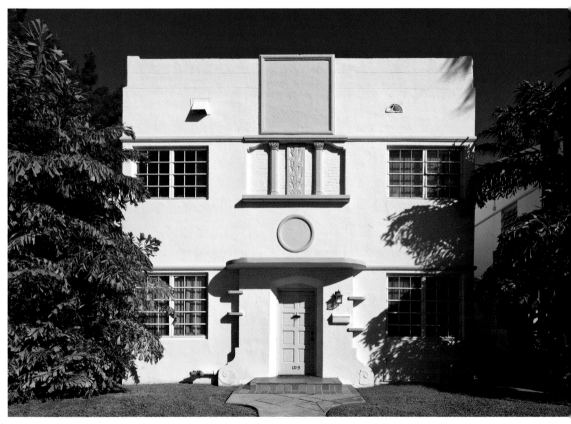

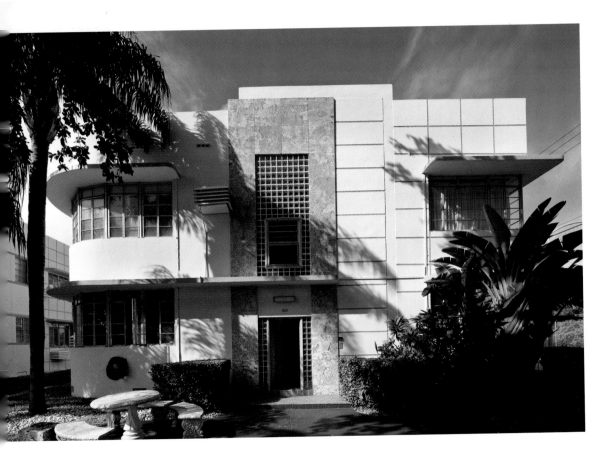

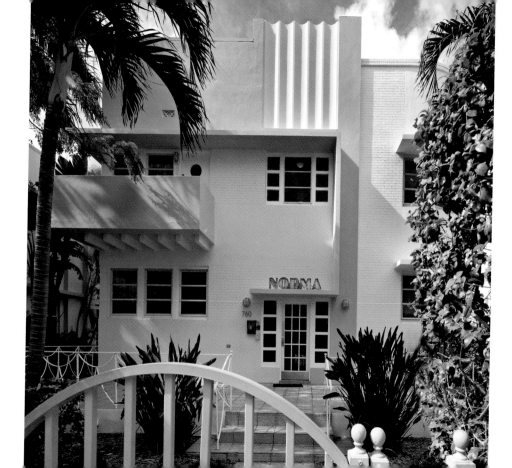

NORMA

760

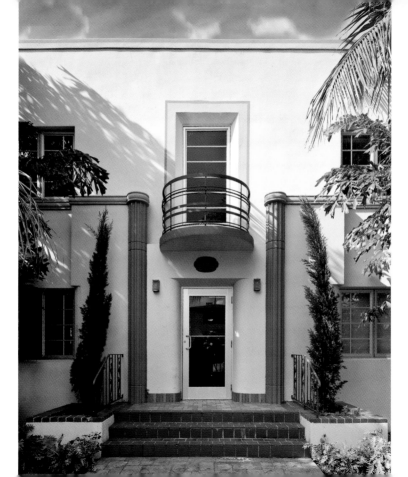

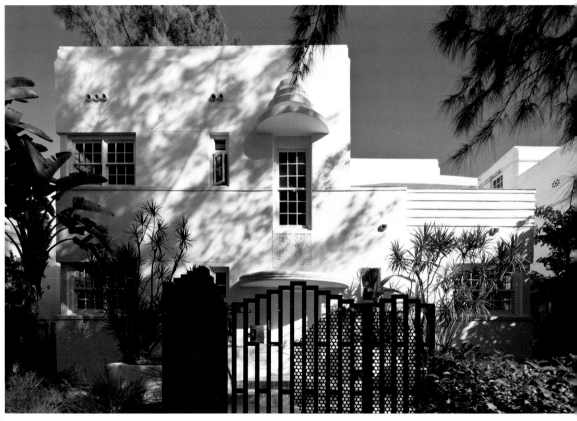

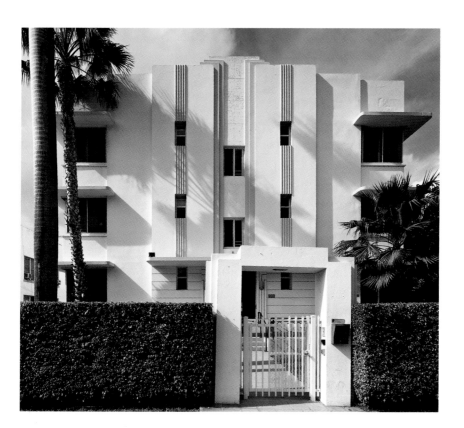

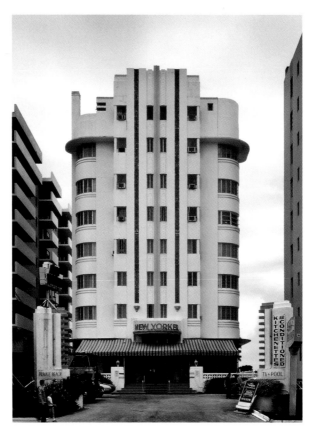

New Yorker Hotel, Demolished, 1981

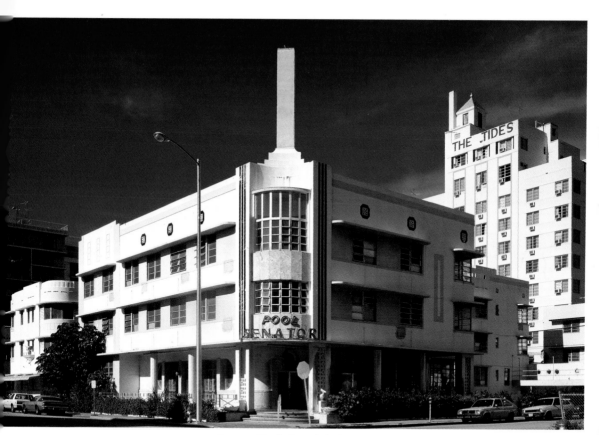

Senator Hotel, Demolished, 1988

INDEX

(Note: Individuals listed below are architects of record; dates given are construction dates.)